IMAGES
of America
SANTA MARGARITA

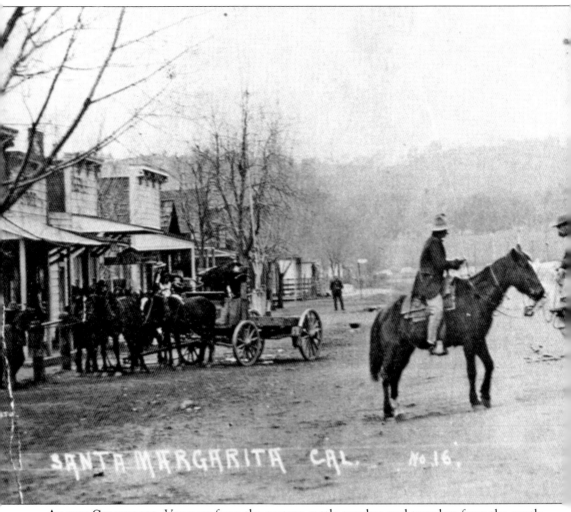

AT THE CROSSROADS. *Vaqueros* from the eastern cattle ranches and travelers from the north and south meet on El Camino Real in Santa Margarita. (Courtesy of the Santa Margarita Historical Society.)

ON THE COVER: As home to Native American tribes, mission padres, and railroad workers for the Southern Pacific Railroad, Santa Margarita has always had a culturally rich assortment of residents working and living side by side. This photograph shows Frank Smith's blacksmith shop next to recent Italian immigrant Louis Zolezzi's store. (Courtesy of the History Center of San Luis Obispo County.)

IMAGES of America
SANTA MARGARITA

Cheri Roe and the Santa Margarita Historical Society

ARCADIA
PUBLISHING

Copyright © 2016 by Cheri Roe and the Santa Margarita Historical Society
ISBN 978-1-4671-3374-6

Published by Arcadia Publishing
Charleston, South Carolina

Printed in the United States of America

Library of Congress Control Number: 2015949511

For all general information, please contact Arcadia Publishing:
Telephone 843-853-2070
Fax 843-853-0044
E-mail sales@arcadiapublishing.com
For customer service and orders:
Toll-Free 1-888-313-2665

Visit us on the Internet at www.arcadiapublishing.com

CONTENTS

Acknowledgments		6
Introduction		7
1.	The First People and the Mission Era	9
2.	Rancho Days	15
3.	Railroad Days	25
4.	School Days	39
5.	The Town of Santa Margarita	49
6.	Rural Santa Margarita	113

Acknowledgments

It is with gratitude that I dedicate this book to the wonderful people of Santa Margarita, who have been extraordinarily generous with their photographs, letters, stories, and time. I would like to recognize Alan Shinn, possibly the most enthusiastic Santa Margarita history buff, for his tireless quest for the town's history. Thank you Eva Ulz from the History Center of San Luis Obispo County for your expertise. Thanks to all my friends at the North San Luis Obispo County History Museums & Societies group for their encouragement. Also, I would like to thank Barbara Arnold, Henry Barba, Peggy Beedle, the Drake family, Charlene Miller Edwards, Rev. Carl Faria at the Diocese of Monterey Archives, Jill Gallagher, the Albert Kelley family, Mel Lusardi, Frank Mecham, Allan Ochs, Milne Radford, Laura Rogers, San Luis Obispo Railroad Museum, Jason Schroder, Michael J. Semas, and Ed Vernon. Thanks to my researchers and fact checkers, Jennifer Hart-Kelley and Pam Parsons; a very special thanks to Pam Parsons for her research tenacity and unwavering support for this book. Finally, I would like to thank my husband, Malcolm, who always said that I should write a book.

If you can identify people in photographs or have additions or corrections, please contact info@SantaMargaritaHistoricalSociety.org.

All images are from the author's collection unless otherwise noted. Abbreviations are used for the following sources:

HCSLOC History Center of San Luis Obispo County
SMHS Santa Margarita Historical Society

The main sources for this work were *Asistencia Santa Margarita de Cortona* by Ed Vernon, *The Protected Valley* by Virginia Williams, *Rails across the Ranchos* by Loren Nicholson, and *History of San Luis Obispo County* by Myron Angel.

Introduction

Ten miles north of the county seat at San Luis Obispo and separated by the Cuesta Grade, Santa Margarita has always been a gathering place. With its year-round running streams and abundant acorns, the valley was a meeting place for northern Chumash and southern Salinan people around 6500 BC. Fr. Junipero Serra founded the Mission San Luis Obispo de Tolosa in 1772. Around 1787, a mission *rancho* was established in the valley to cultivate wheat and graze cattle. The rancho was named for the Italian saint Margarita de Cortona. In 1819, the San Luis Obispo Mission began construction of a stone building that became an *asistencia* or extension to Mission San Luis Obispo.

In 1841, after Mexico's independence and secularization, Joaquin Estrada became the owner of the Santa Margarita Rancho. Estrada was famed for his rancho hospitality, hosting rodeos, barbecues, and fiestas. After downturns in the economy, personal debts, and independence from Mexico, Estrada sold the rancho to the Martin Murphy family in 1860.

Son Patrick Murphy worked to restore the rancho to an operational agricultural ranch. On April 20, 1889, the Southern Pacific Railroad reached Santa Margarita from Templeton. A Grand Auction was held to sell lots for the new town of Santa Margarita along El Camino Real. This created a boom time in the community. While construction over the Cuesta Grade took place, the railroad terminus was in Santa Margarita. All freight had to be loaded for stage transport up and down the Cuesta Grade. The town boasted two hotels, several restaurants, and lots of taverns, dance halls, blacksmiths, and ice cream parlors. Once the gap was closed from Santa Margarita to San Luis Obispo in 1894, the town grew quiet. Santa Margarita saw a renaissance at the turn of the 20th century. After Patrick Murphy's death, the Santa Margarita Rancho was sold to Fernando "Frank" Reis in 1901. Some parts of the ranch were cut up for development, including Garden Farms, just north of Santa Margarita on El Camino Real.

The automobile heralded a new transportation age. El Camino Real was the perfect road for seeing California. The town included a motor inn, a hotel, six gas stations, garages, pool halls, restaurants, fraternal organizations, taverns, a new schoolhouse, and a baseball team. The Depression hit the town and the surrounding areas hard. But tough times make tough people, and the residents of Santa Margarita pulled together. World War II brought more changes to the area. The War Department took land from local farmers to build a reservoir on the Salinas River, creating Santa Margarita Lake and providing water for Camp San Luis. After the war, Santa Margarita Lake was converted into a water source for the city of San Luis Obispo, and it is now a county recreation area.

When Highway 101 bypassed Santa Margarita in 1956, the town grew quiet once again. However, community spirit was as strong as ever. By the mid-1960s, a new community park was built by town volunteers, and a new post office and schoolhouse were erected. The library was relocated from the post office to the old constable's house near the new community center. The Days of the Dons celebration, a remnant from Joaquin Estrada's rancho era, returned in 1965 after a 23-year

hiatus. Unfortunately, progress at that time meant tearing down older structures, including the railroad depot and much of downtown.

The Carrizo Plain Natural Area, which became a national monument in January 2001, is significant for its geological, biological, and cultural resources. Santa Margarita is proud to be the gateway to the Carrizo Plain National Monument.

Today, Santa Margarita is the same half-square-mile area originally planned in 1889. Landlocked by the Santa Margarita Ranch, this quaint artist and family community of 1,259 people enjoys the best of small-town living in one of the most beautiful places in California. The town has many organizations, including the Santa Margarita Historical Society, the Santa Margarita Lions Club, Friends of the Santa Margarita Library, the Santa Margarita Volunteer Fire Department, Santa Margarita Community Forestry, Santa Margarita Beautiful, Carrizo Plain Gateway Committee, PTA, 4H, and Girl Scout and Boy Scout troops. The town supports two churches, Santa Margarita Community Church and Santa Margarita de Cortona Catholic Church.

One

THE FIRST PEOPLE AND THE MISSION ERA

When Spaniard Juan Rodriguez Cabrillo arrived in California in 1542, the Chumash were one of California's largest tribes, numbering as many as 22,000 people. The Chumash were one of the most complex and highly organized California tribes. They had at least six regional groups, all speaking the same language and sharing the same cultural and political structure. The Chumash lived along the coast of California from Malibu in Los Angeles County to the south, throughout Santa Barbara County and north to Morro Bay in San Luis Obispo County. The smaller Salinan tribe predominately lived in the Salinas Valley extending from the vicinity of Mission San Antonio in Monterey County to Mission San Miguel in San Luis Obispo County as well as along the coast from San Simeon to the end of the Santa Lucia mountain range in Monterey County. Santa Margarita Valley was an area where the Chumash and Salinan tribes may have lived in relatively close contact. In the valley they found abundant wildlife, including deer, bears, and rabbits, as well as an ample supply of acorns and year-round running streams.

When the Spanish explorers arrived in the area in 1769, the Franciscan friars and soldiers drafted the Chumash and Salinan people into settlements. These native people provided labor to build and supply the asistencia of Santa Margarita, an outlying farm that supported Mission San Luis Obispo de Tolosa, founded in 1772. The exact date of the founding of the asistencia is unknown, but is believed to be soon after the founding of Mission San Luis Obispo de Tolosa by Fr. Junipero Serra. It is thought that the asistencia was named to honor Father Serra's mother, Margaret, and his order's favorite saint and patroness, Santa Margarita de Cortona.

After Mexico declared its independence from Spain in 1810, the mission system was seriously set back by the lack of funds and supplies. In 1821, after 11 years of war, the people of New Spain won their independence and formed the Republic of Mexico.

In 1833, the missions' holdings were broken up by the Mexican government and passed from control of the Catholic Church into the hands of private Mexican landowners.

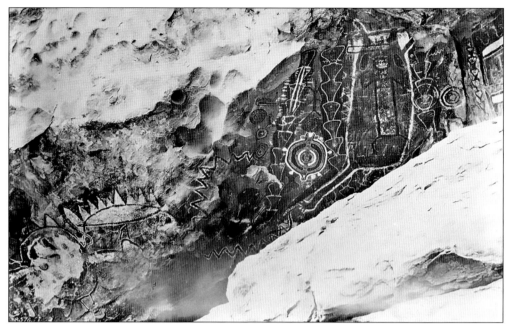

CHUMASH PICTOGRAPHS. The Chumash were some of the finest rock painters in North America. Similar rock art is found near Santa Margarita. The true meaning of these ancient images is not known, but they appear to depict animals and objects such as the sun. They may have been painted as a form of communication or by shamans during ceremonies. Chumash rock sites are now protected by the National Park Service. (Courtesy of USC Digital Archive © 2004, California Historical Society: TICOR/Pierce, CHS-8576.)

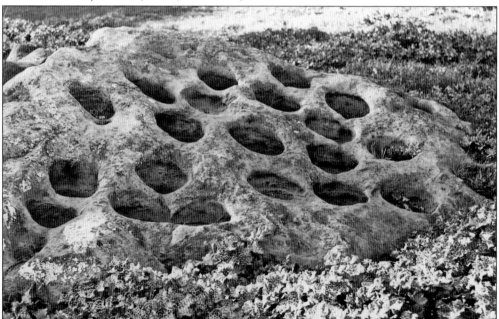

GRINDING HOLES. Holes in the hard, flat rocks are prevalent on the Santa Margarita Ranch. Man-made holes were used to grind acorns. The Chumash used every available source of food. In addition to acorns, their diet included wild game, seeds, shellfish, and fish. (SMHS.)

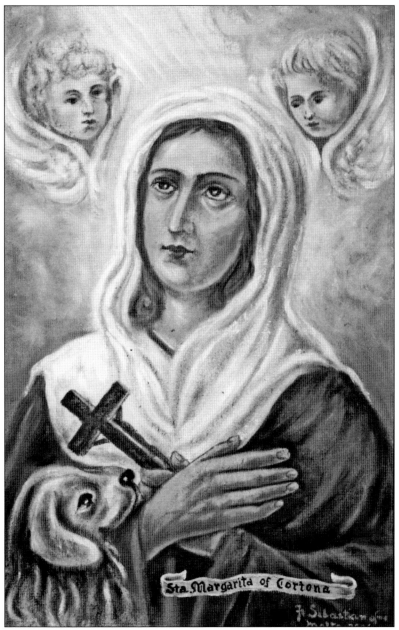

SANTA MARGARITA DE CORTONA. Saint Margaret (1247–1297) was born in Laviano, near Cortona, in the province of Tuscany, Italy. She was a favorite patroness of Mallorca, Spain, the birthplace of Fr. Junipero Serra (1713–1784). There are three distinct histories of Saint Margaret, including the story that she was a virgin saint and a slayer of dragons. The most accepted history is that she was a young girl with a wicked stepmother and an unsympathetic father. A natural beauty, young Margaret left home to make her life among strangers. A nobleman led her astray and was later murdered. In penitence for her sins, Margaret journeyed to Cortona and was allowed to join the Third Order of Saint Francis. Pope Benedict XIII canonized her in 1728. Fr. Sebastian Scicluna painted this portrait for Fr. Joseph Grech. It hangs in the Santa Margarita de Cortona Catholic Church in Santa Margarita. (Photograph by Jill Gallagher, 2012.)

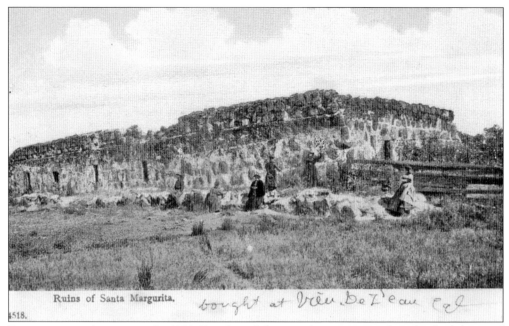

PICNIC AT THE ASISTENCIA. In 1830, Fray Luis Gil wrote that recent earthquakes had damaged "all the walls of the house at Santa Margarita." When Joaquin Estrada acquired the Rancho Santa Margarita Mexican land grant in 1841, the mission was in ruins. Estrada moved into an existing adobe several hundred yards south of the asistencia.

THE ASISTENCIA IN RUINS. Viewed from the south, this photograph, taken before 1904, shows

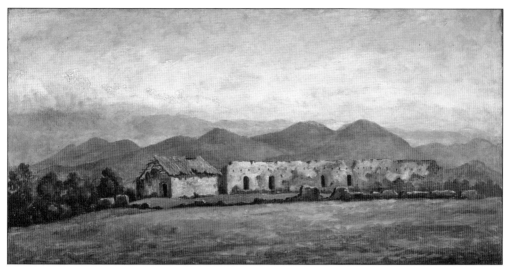

WATERCOLOR OF THE ASISTENCIA. Several drawings of the asistencia were completed after the Martin Murphy family acquired the Santa Margarita Ranch in 1861. Henry Chapman Ford created this 1881 watercolor from a sketch he made during a previous visit. Ford was born August 6, 1828, in Livonia, New York. He studied art in Paris and Florence in the late 1850s. During the Civil War, he was assigned to draw illustrations for the military. He then moved to Chicago, where he was employed as a landscape painter for the city. His studio was destroyed in the great Chicago fire of 1871. Suffering from health problems and the need to move to a warmer climate, he came to Santa Barbara, California, in 1875. He toured the state and made etchings, watercolors, and oils of all 21 of the California missions. These drawings and paintings were partly responsible for the revival of interest in and restoration of the missions. In 1883, he published *Etchings of the Franciscan Missions of California*. His work was exhibited at the Chicago World's Fair in 1893. He died February 27, 1894, in Santa Barbara. (Courtesy of the Mission Inn Museum.)

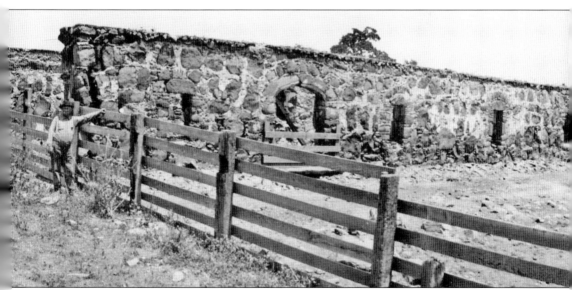

the destruction of the upper part of the wall and the fallen wall of the chapel. (SMHS.)

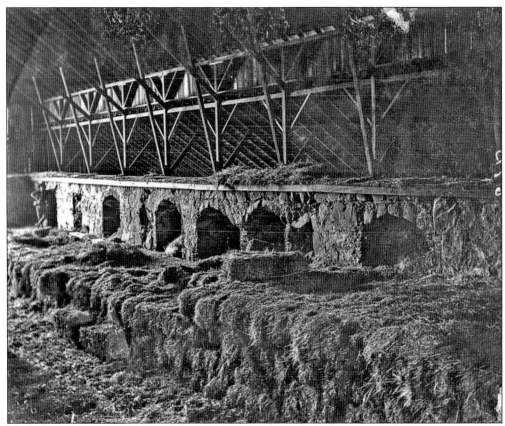

ASISTENCIA HAY STORAGE. According to a *Los Angeles Times* story on July 3, 1949, the first crop of hay stored shortly after the interior walls were demolished caught fire and burned. The heat from the blaze blackened the walls and may have loosened the mortar. (Photograph by Terry Ruscin, 1998.)

ASISTENCIA TODAY. The roof supports were removed to relieve pressure on the stone walls. The asistencia has been covered by rustic wood siding with a metal roof to protect the structure. It is now used for weddings and as an event center. It is on private land and is a California state historical landmark. (Photograph by Ed Vernon, 2012.)

Two

Rancho Days

Mexico declared its independence from Spain on September 16, 1810. After a protracted war, Spain recognized Mexico's independence in 1821. In 1832, the Mexican government ordered all mission lands secularized and awarded to private landowners through land grants. In 1841, Joaquin Estrada was granted the 17,735-acre Rancho Santa Margarita de Cortona. His brother Pedro Estrada was granted the neighboring 39,225-acre La Asuncion Rancho in 1845. Don Joaquin Estrada was famous for his huge cattle herds and Mexican rancho hospitality. His Days of the Dons celebration, commemorating Mexico's independence, would last for weeks and feature rodeos, horse races, and barbecues.

After California's independence from Mexico in 1848, a devastating drought, a downturn in the economy, and personal debts, Estrada sold the Rancho Santa Margarita to the Martin Murphy family in 1860. Joaquin Estrada went on to be an influential fixture in the county. He was San Luis Obispo County's first District Five supervisor and the first county treasurer. Eventually, he relocated to the foot of the Cuesta Grade to build the beautiful Estrada Gardens, where he died in 1893. Joaquin Estrada had 11 children. His son Fernando and Fernando's wife, Rosa, had 19 children. Many Estrada family descendants still live locally.

Martin Murphy combined the Rancho Santa Margarita, the Asuncion Rancho, and neighboring Atascadero Grant and appointed his son Patrick as overseer of nearly 70,000 acres. Patrick Murphy continued the rancho hospitality tradition from Don Joaquin Estrada's time. Murphy also lived in the adobe portion of the mission. He installed wood siding and an indoor kitchen and updated the structure in a Victorian style. His wife, Mary Kate, was the daughter of Dr. Patrick M. O'Brian, a physician and prominent citizen of early San Francisco and San Jose. Mary Kate died young. Patrick Murphy never remarried and had no children. He recognized that having a railhead nearby would vastly improve his cattle and land values. On April 20, 1889, in a partnership with the Southern Pacific Railroad, he brought the train to Rancho Santa Margarita to great fanfare with a barbecue and land auction for the new town, Santa Margarita.

Patrick Murphy led a successful life in San Luis Obispo County. He served in the state assembly and was elected state senator three times. The Rancho Santa Margarita de Cortona was sold to San Francisco land developer Ferdinand Reis on March 8, 1901, for $220,000. Patrick Murphy died in San Francisco on November 1, 1901.

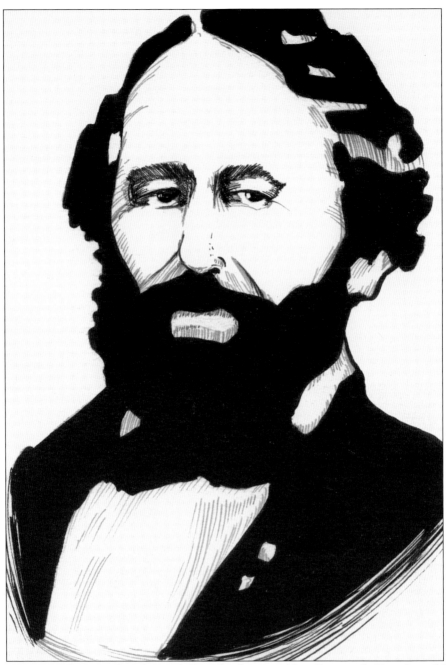

JOAQUIN TOMAS ESTRADA (1815–1893). Estrada, the son of Jose Raymundo Estrada and Maria Josefa Vallejo de Alvarado, was born in Monterey, the capital of Alta California. The Estrada family was influential in early California history. Joaquin's older half-brother, Juan Bautista Alvarado, was governor of California from 1836 to 1842. In 1841, secretary of state and acting governor Manuel Jimeno Casarin granted 17,735 acres to the 26-year-old Joaquin Estrada. The ranch was rated "first class" and taxed at $1.25 an acre. Joaquin Estrada and his Rancho Santa Margarita were famous for traditional Mexican rancho hospitality. This sketch is based on an original newspaper photograph from *Atascadero News*. (Art by Jason Schroder, 2014.)

ESTRADA CATTLE BRAND. Estrada devoted his time to raising large herds of Mexican cattle, which were mean, lean, short-haired animals with long, thin legs and long horns. Because there were no fences, cattle ranged over large distances and would often mix with cattle from other ranchos. To establish ownership, each rancher had their own brand. Joaquin Estrada's brand was an "E". Every spring, the vaqueros would round up the cattle and sort out which animals belonged to which rancho based on the brands. As the days of hide and tallow were waning, Joaquin Estrada made much of his wealth in the cattle that were driven to the goldfields after the Gold Rush began in 1848. By 1859, severe drought dried up the creeks and killed the grasses. As debts piled up, Joaquin Estrada sold the Santa Margarita Ranch in 1860 to the Martin Murphy family for $45,000. (SMHS.)

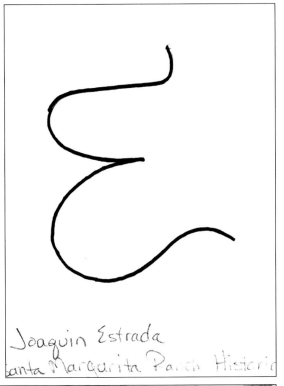

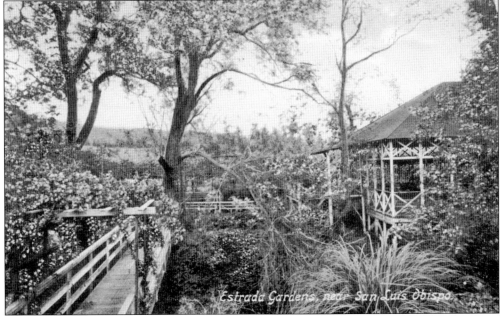

ESTRADA GARDENS. After Joaquin Estrada sold the Rancho Santa Margarita to the Martin Murphy family, he retired to the foot of the Cuesta Grade to build his 200-acre family home, Estrada Gardens. His new home afforded conditions that were perfect to grow lavish ornamentals and citrus. Joaquin Estrada died in 1893 and is buried in an unmarked grave on this private property. (SMHS.)

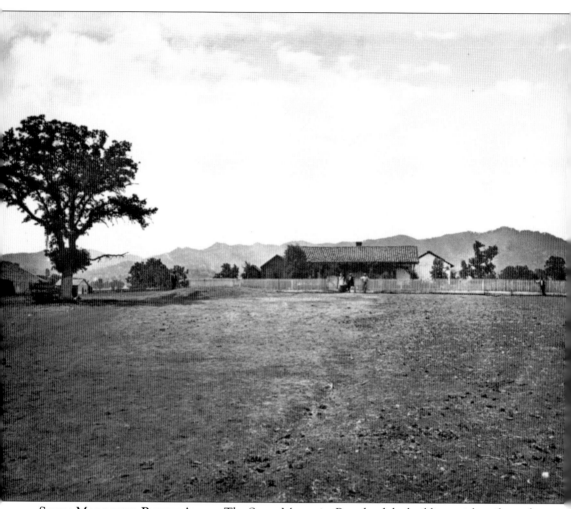

Santa Margarita Ranch Adobe. The Santa Margarita Ranch adobe building, with a tile roof, first housed mission priests and later the Estrada and Murphy families. This photograph was taken around 1876 by Carleton Watkins (1829–1916). Watkins gained fame in the 1860s for his views of the Yosemite Valley. Throughout his career, Watkins documented the remote west, generating more than 7,000 photographs of majestic wilderness sites. In 1864, his photographs of Yosemite Valley proved instrumental in convincing Pres. Abraham Lincoln and the 38th US Congress to pass the Yosemite Valley Grant Act, setting a precedent for the National Park System. As a close friend of Collis P. Huntington, one of the executives of the Central Pacific Railroad and its extension, the Southern Pacific Railroad, Watkins photographed much of the rail lines. Watkins was more of an artist than a businessman. He lost his collection in an 1874 bankruptcy caused by the Bank of California failure. He rebuilt his collection, only to lose it in the 1906 San Francisco earthquake. He suffered ill health and blindness. He never recovered from losing his life's work and in 1910 was moved to Napa State Hospital for the Insane, where he died at the age of 87. Early photographers like Watkins were invaluable in documenting the nation's history. (Courtesy of the Metropolitan Museum of Art, www.metmuseum.org.)

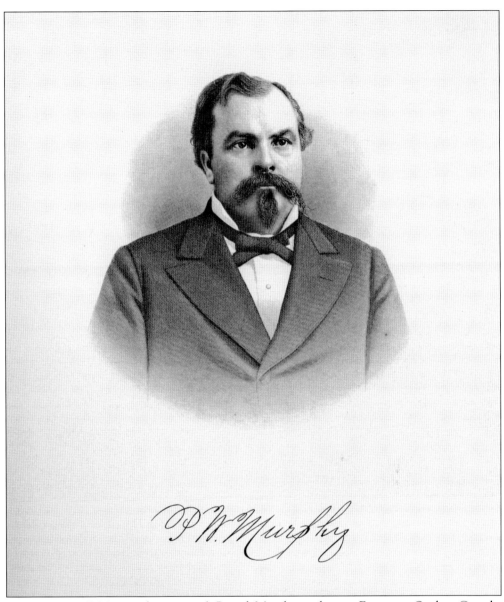

Gen. Patrick W. Murphy (1837–1901). Patrick Murphy was born in Frampton, Quebec, Canada. He first immigrated to Missouri, then onward to California with his parents and grandparents; the Murphy family traveled with the Murphy-Townsend-Stephens Wagon Train in 1844 over what is now the Donner Pass, two years before the Donner party. Younger sister Elizabeth Yuba Murphy was the first Anglo child born in California during this trip. The family settled in Santa Clara Valley. Patrick's parents, Martin Jr. and Mary Bulger Murphy, purchased the Santa Margarita Ranch from Joaquin Estrada in 1861 for $45,000. At 25 years old, eldest son Patrick Washington Murphy took charge of the cattle ranch. He became a prominent businessman, an originator of the San Luis Obispo Water Company, and incorporator of the Bank of San Luis Obispo. He served in the state assembly and was elected state senator three times. Murphy died eight months after selling the ranch to Ferdinand Reis. (Courtesy of the California Historical Society.)

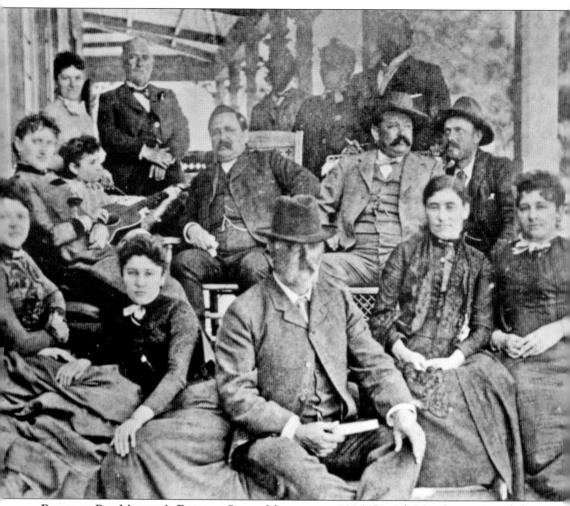

PARTY AT PAT MURPHY'S RANCHO SANTA MARGARITA, 1895. Patrick Murphy continued the rancho hospitality famous during Joaquin Estrada's time. Pictured here from left to right are (first row) Martha Graves (wife of Madison), Nellie Dana (daughter of Blandina and Charles Dana), George Robbins, Lucinda Graves (wife of Ernest), and Blandina Dana; (second row) Catherine Robbins, Fidelia Dana (daughter of Blandina and Charles Dana), Ernest Graves, Madison Graves, and C.C. Lambert; (third row) Mrs. Carroll, Charles Dana, Mrs. Harris, Andronico Soto, and Pat Murphy. (HCSLOC.)

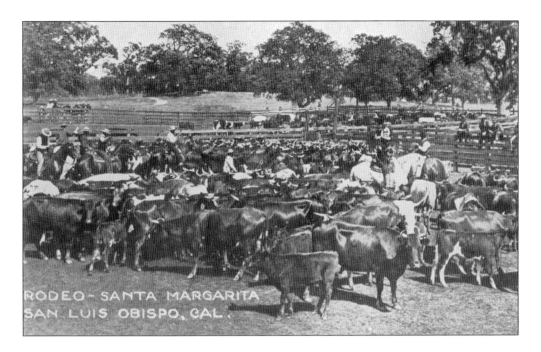

CATTLE BRANDING AT SANTA MARGARITA RANCH. These c. 1910 postcards show scenes from a cattle roundup, in those days commonly called a rodeo. The vaqueros rounded up the cattle for counting, sorting, and branding. They would be herded into corrals and sorted by rancho based on the brand on each animal. Since calves always stayed with their mother, it was easy to determine which belonged to the ranch, and the calves would then be branded. The vaqueros also had to count the cattle so the rancho would know how many cattle were in the herd. After days of hard work, the round-up would be followed by a fiesta. (Both, SMHS.)

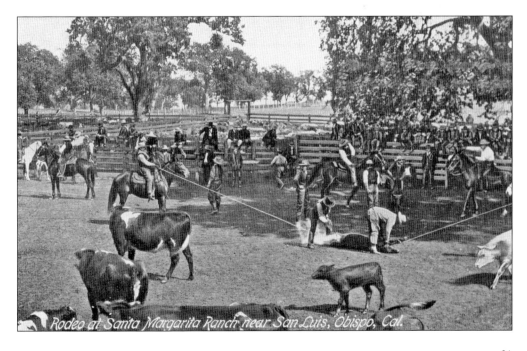

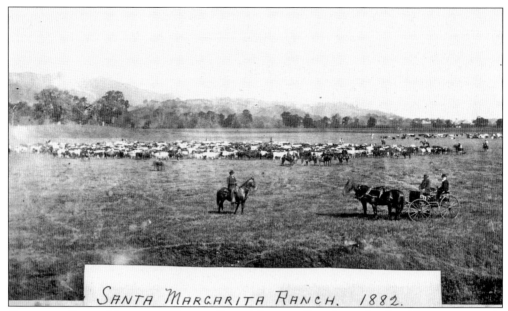

CATTLE ON SANTA MARGARITA RANCH. Santa Margarita Ranch may be the oldest continuously running cattle ranch in California. At one time, the Murphy ranch counted 200,000 cattle, many of them completely wild. Cattle continued to be the major source of income as Murphy explored other crops, including sugar beets. In a map from 1858, a cattle trail is marked on the eastern boundary of the ranch. This photograph was taken by Dr. John Gallway. (HCSLOC.)

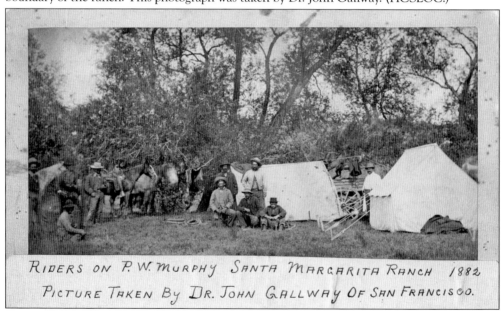

GALLWAY HUNTING PARTY. Prominent San Francisco physician Dr. John Gallway was related to the Murphy family through his uncle and mentor, Dr. James Murphy. He was an early photography enthusiast, combining hunting and photography. An 1893 *San Francisco Chronicle* newspaper article reported that on one such trip, "Affairs have come to such a pass that no one is willing to believe their stories [about hunting] without something more substantial than their words and that something has been found in a camera." (HCSLOC.)

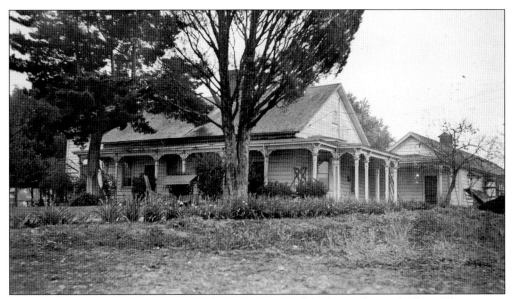

SANTA MARGARITA HEADQUARTERS. This structure is adobe beneath wood siding. The current Santa Margarita Ranch Headquarters was built by Father Luis Antonio Martinez around 1830 to provide living space for priests and visiting church officials. It is historically intact. During the rancho period, the priests' quarters were used to house vaquero and ranch hand employees. Today, the priests' quarters are vacant and have suffered from earthquakes and wet weather. This mid-1900s photograph shows the building before the kitchen was added. (Courtesy of Braun Research Collection, Autry Museum, Los Angeles; P.18105.)

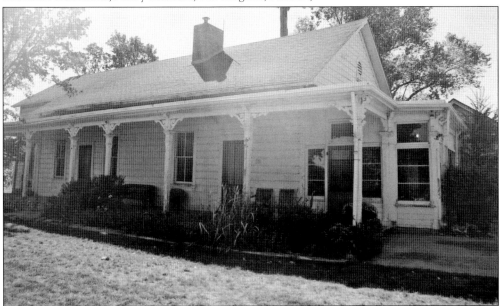

PRESENT-DAY HEADQUARTERS. This photograph shows the residential portion of the Santa Margarita Ranch Headquarters. Although wood siding has been placed over the exterior adobe walls and a kitchen has been added inside the house, the interior walls are still plastered with deep inset windows. This part of the headquarters building has been used almost continuously as a residence since it was built.

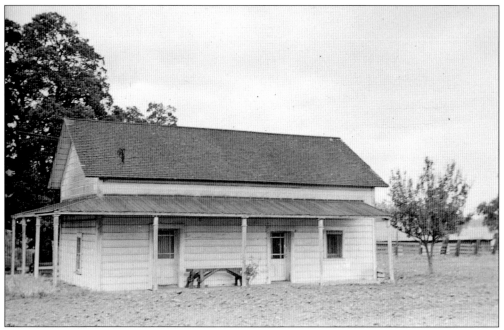

WELLS FARGO BUILDING. The Santa Margarita Wells Fargo stage stop was an original stop along El Camino Real. The first official US post office for Santa Margarita was located in this building from 1867 until 1881. It was also used as a general store. (Courtesy of Braun Research Library Collection, Autry Museum, Los Angeles; P.18107.)

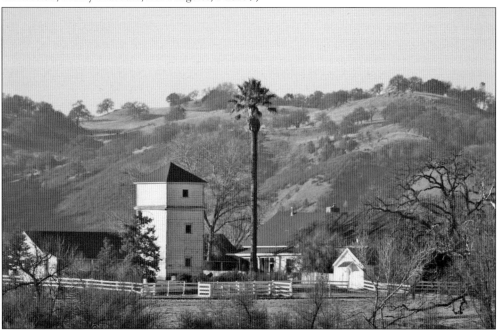

PRESENT-DAY HEADQUARTERS. Nestled in the valley, the Santa Margarita Ranch has mild weather and outstanding views. This 2007 view shows the back of the headquarters buildings. The small building on the right was used as an office. The building on the left was the padres' quarters. The tall structure is the well's pump house.

Three

Railroad Days

After its arrival in 1886, the Southern Pacific Railroad was stalled in Templeton, 15 miles north of Santa Margarita and 125 miles north of the nearest terminus in Santa Barbara.

To close the gap between San Luis Obispo and Templeton, the Southern Pacific demanded a free right-of-way through the Santa Margarita Ranch, as well as 640 additional acres of land for a town site. The ranch's owner, Patrick Murphy, was apparently willing to give the land for the right-of-way, but he held out against the free land for a town site. He wanted an arrangement to share the profits from the development of a town on his land. Finally, in 1888, an agreement was reached between Murphy and the Southern Pacific. The railroad would get the right-of-way through his land, and Murphy would share in the profits of the town development.

On April 20, 1889, the Southern Pacific Railroad arrived in Santa Margarita with great fanfare. Advertisements were placed in every newspaper between Santa Barbara and San Jose. An auction was to be conducted by two San Francisco firms, and Murphy and his vaqueros planned a barbecue.

Some 320 acres of town lots had been laid out, with a main street facing the railroad tracks. Farm parcels outside of town would be sold to the highest bidders. The fate of Santa Margarita was bound to the uncertain acts of the railroad. The situation created both hope and despair. Buyers of lots paid 25 percent down, with the balance due in three payments over 18 months at 10 percent interest. Investors hoped for fast construction of tracks and tunnels down the Cuesta Grade and into San Luis Obispo. But work was stalled again, and many buyers never made a second payment.

By 1892, work continued south of Santa Margarita on tunnels and tracks. During this time, the town enjoyed its status as a terminus, as southbound freight and passengers had to be off-loaded and transported to San Luis Obispo. The gap was closed in 1894, and the Southern Pacific Railroad continued into San Luis Obispo.

GRAND AUCTION SALE. Reporting on the April 20, 1889, auction, the *San Luis Obispo Daily Republic* newspaper stated, "The new town of Santa Margarita was introduced to the world on Saturday last under the most flattering prospects. Everybody knows that Santa Margarita is a lovely valley and it becomes very popular to say so, therefore when the opportunity was offered under liberal advertising it was lauded to the skies and everybody wanted to see the famous spots. The Grand Auction drew perhaps a thousand people from the surrounding country and along the Salinas Valley and four or five hundred people came from San Francisco." Prices for lots were fixed from $100 to $500. According to the auctioneer, Samuel W. Fergusson, of the real estate firm Briggs, Fergusson & Co. of San Francisco, nearly four downtown blocks were sold during the day for a total of about $21,000. (HCSLOC.)

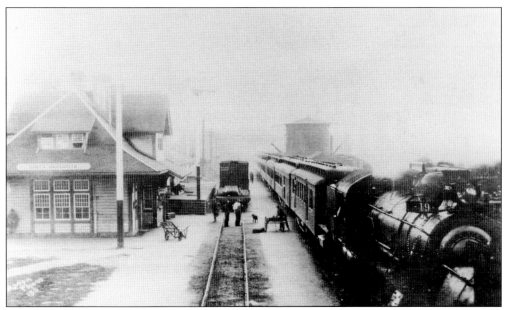

SOUTHERN TERMINUS FOR THE RAILROAD. From April 20, 1889, until May 5, 1894, Santa Margarita was the southern terminus for the Southern Pacific Railroad. All southbound freight had to be offloaded for the arduous wagon trip over the Cuesta Grade. The stagecoach route was a steep road that saw many accidents. It was during the construction over the grade into San Luis Obispo that the first true road between the two towns was constructed by Sandercock Drayage. (HCSLOC.)

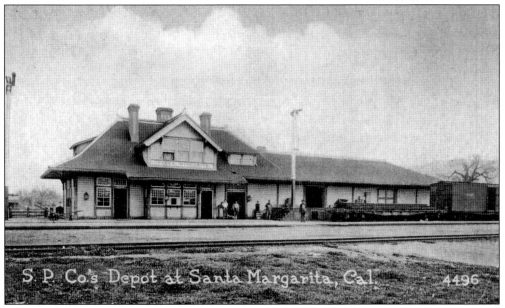

SOUTHERN PACIFIC DEPOT. With the tracks paralleling El Camino Real, the Santa Margarita depot was positioned facing H Street between Murphy and Margarita Streets. The majority of the depot was for freight, with a station manager's office, a baggage area, and a waiting room. Across the street was the Lauritson Brothers' General Merchandise Store and the pool hall. On the other side of the tracks was El Camino Real, with hotels, restaurants, saloons, and a dance hall. (SMHS.)

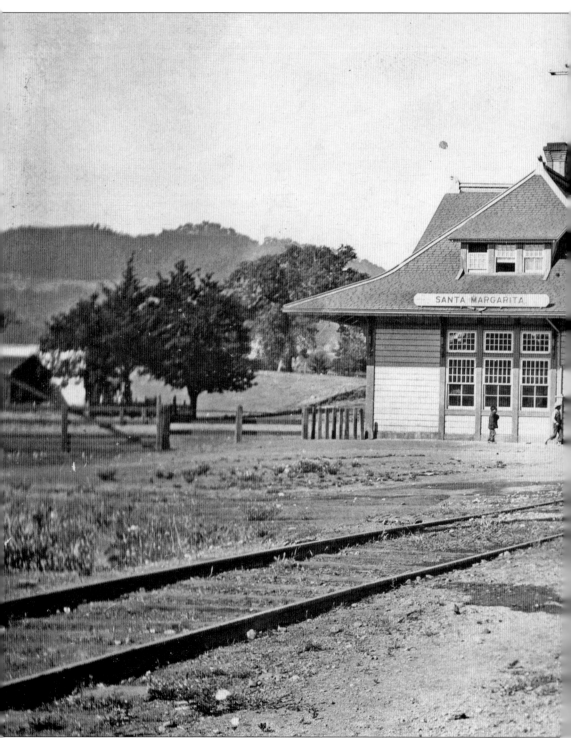

Locomotives Added for Cuesta Grade Trip. After the rail line was extended south into San Luis Obispo in 1894, northbound helper locomotives were added in San Luis Obispo and removed in Santa Margarita. In Santa Margarita, southbound trains needed the extra locomotives to slow

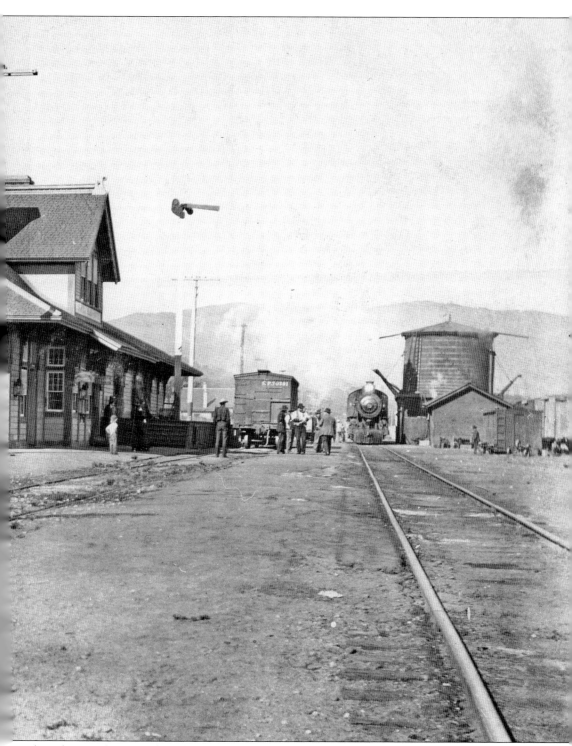
them down and prevent them from barreling down the hill. Instead of a turntable, Santa Margarita used a wye track to add and remove locomotives. (SMHS.)

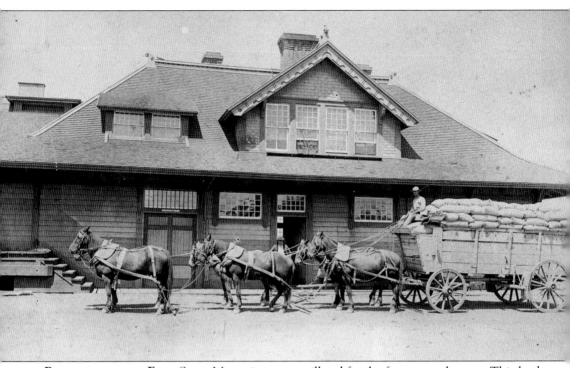

RAILHEAD FOR THE EAST. Santa Margarita was a railhead for the farmers to the east. This load of flour was hauled by Walter Brown in 1891 for the Sperry Flour Company from the Carrizo Plain, 66 miles east of Santa Margarita. In addition to the grain and cattle grown on the Santa Margarita Ranch, farmers from the outlying areas of the Carrizo Plain, Pozo, Las Pilitas, and La Panza found the terminus at Santa Margarita to be more advantageous than transporting farther east to the San Joaquin Valley. The Hubbard Flour Mill also hauled flour from the Carrizo Plain to Santa Margarita for shipping. Goods were also received from the railroad for the local farmers and ranchers. Canned goods, farm machinery, fencing, and building materials all arrived by the railroad. (HCSLOC.)

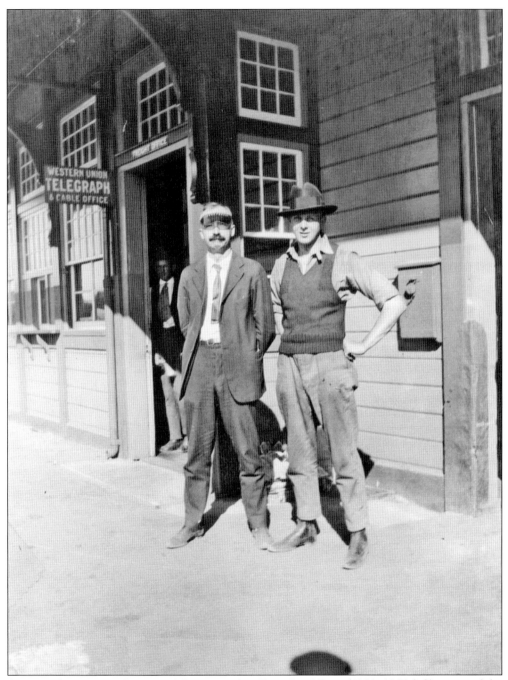

STATION AGENT AND BAGGAGE MANAGER. Guy Roy "Doc" Derr (1880–1967, left), agent of the Santa Margarita Southern Pacific depot, poses with Gordon Taylor, telegrapher. Doc Derr was the agent for a number of years from the late 1920s through the early 1940s. He was well known for running an English numbers game called raffle ticket sales, which were similar to a lottery. (SMHS.)

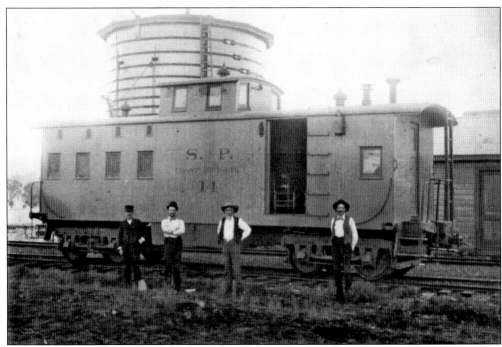

WATER TANK. The steam locomotives required lots of water, which was first supplied via a wooden tank and later by a steel tank. Santa Margarita's main well is just across the tracks on El Camino Real. (SMHS.)

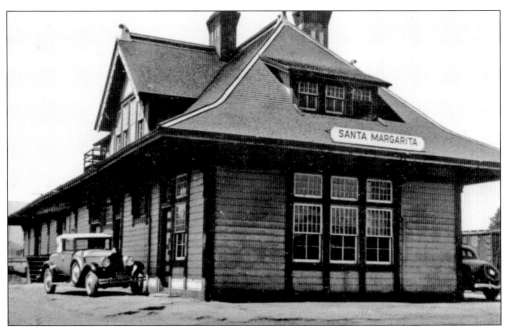

SOUTHERN PACIFIC DEPOT, 1936. After Calf Canyon Highway (later California State Highway 58) was completed, transportation by automobile to the oil fields of McKittrick became commonplace. Oil speculators would travel by railroad to Santa Margarita, **then journey eastward** by fancy cars to the newly prosperous oil fields. (HCSLOC.)

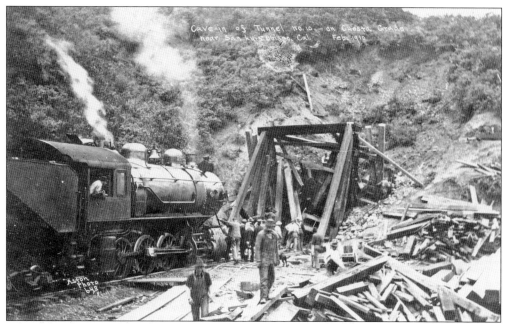

TUNNEL CAVE-IN. On February 10, 1910, at 12:45 a.m., the No. 10 tunnel on Cuesta Grade gave way, smashing the timbers used to prop up the tunnel sides. Fortunately, the train had cleared the tunnel, and no one was inside at the time of the cave-in. Tunnel No. 10 is the third tunnel on the Cuesta Grade from San Luis Obispo. In the wake of the collapse, passengers and mail were transferred around the tunnel to waiting trains on either side of the cave-in. A newspaper reported that it would take 300 men to clear the track and a week to make repairs. But the weather was clear, and the walk around the scene was a mere break in a long train journey. When cave-ins occurred in rainy weather, travelers had to wade through the adobe mud. (Both, SMHS.)

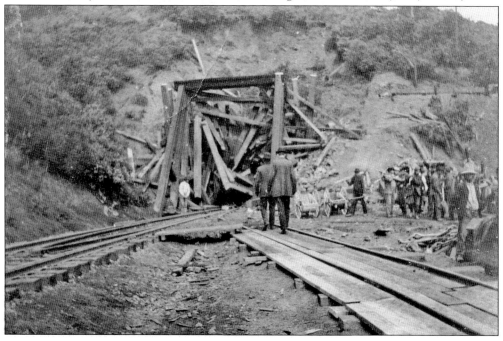

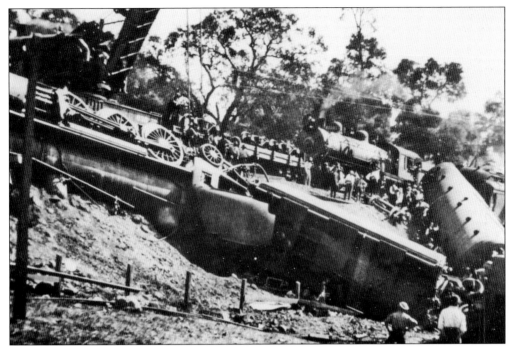

WRECK ON LARK. On October 2, 1915, at 3:45 a.m., the first section of a northbound train, the No. 76 *Lark*, went into a ditch between San Luis Obispo and Santa Margarita. Fireman F.A. Melville of San Francisco was killed, and eight crewmen were injured. No passengers were injured, but those in the front Pullmans were considerably shaken up. The location was a mile and a half from the Cuesta Grade on the Santa Margarita side. An engine and its tender, the baggage car, and the mail car lay in the ditch. The engine was turned wrong side up, while the others were on their side. The diner car was entirely off the rails, and the first Pullman was off with the front trucks. The balance of the train remained upright. Conditions showed that the track had been torn up by the tender of the helper engine in front of the regular engine. The tender went off the tracks just as the train emerged around the first curve from the last tunnel going toward Santa Margarita. (Both, HCSLOC.)

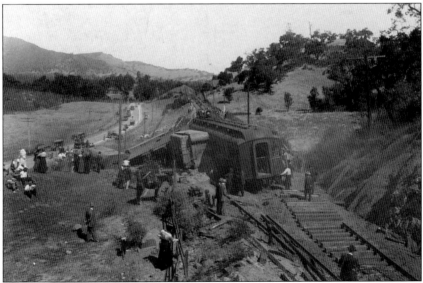

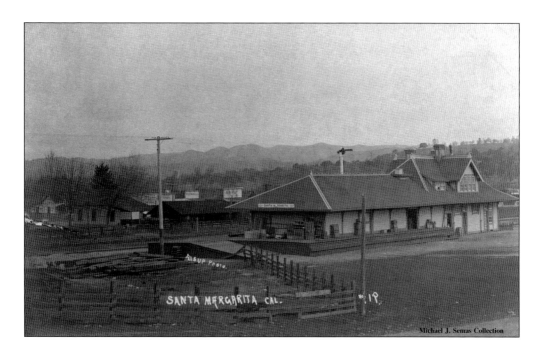

SANTA MARGARITA DEPOT. These postcards show the newly completed 1889 Southern Pacific Railroad depot at Santa Margarita. In the background is the Olive Branch Saloon on El Camino Real. Telephone lines arrived with the Southern Pacific Railroad in 1889. The first telephone directory, in 1903, lists Louis Zolezzi as the telephone agent and only has one listing in town, for F.H. Smith, a blacksmith. Electricity did not reach Santa Margarita until 1913. (Above, courtesy of Michael J. Semas; below, SMHS.)

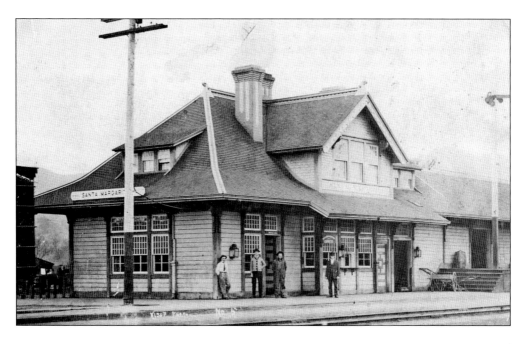

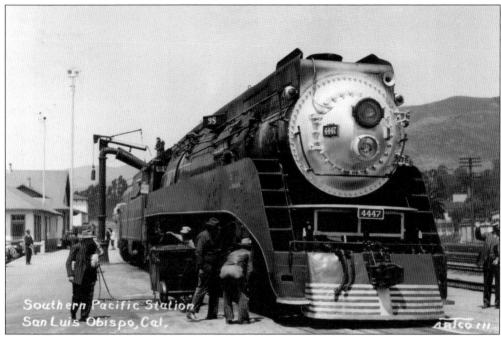

JUNE 8, 1947, POSTCARD. The Southern Pacific *Daylight* is pictured at the San Luis Obispo train station. On March 2, 1941, the *Lark*, a night train, became a streamlined, 12-hour train with cars in shades of gray pulled by the same locomotives that pulled the *Daylight* Pullman cars. The *Lark* had three of the five types of pre-war, lightweight Pullman cars. (Courtesy of Michael J. Semas.)

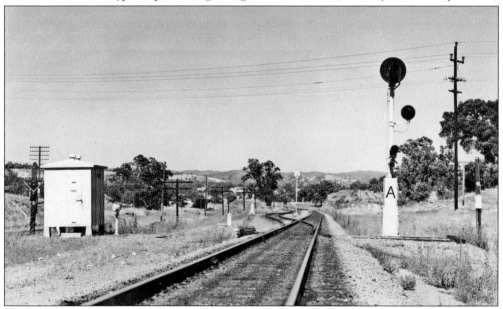

RAILROAD SIGNAL AT SANTA MARGARITA. The Union Switch & Signal Co. of Swissvale, Pennsylvania, took this 1944 photograph of its signal south of the Santa Margarita depot. These signals were placed at railroad crossings for the trains, not for cars. Santa Margarita has three roads that cross the railroad tracks in the middle of town that were not signaled until the 1940s and were often the scene of horrific accidents. (SMHS.)

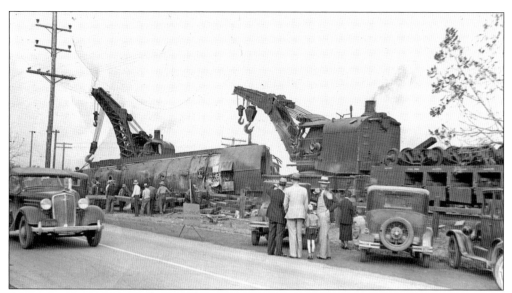

ANOTHER TRAIN WRECK. The track between Santa Margarita and San Luis Obispo was especially dangerous. The steepness of the track, coupled with heavy loads, tunnels, bridges, unsecured road crossings, and unpredictable weather meant plenty of accidents in just a few short miles. Sometimes, trains would run headlong into each other. At other times, one train would ram another. A train wreck brought the people of Santa Margarita out to watch the excitement. (SMHS.)

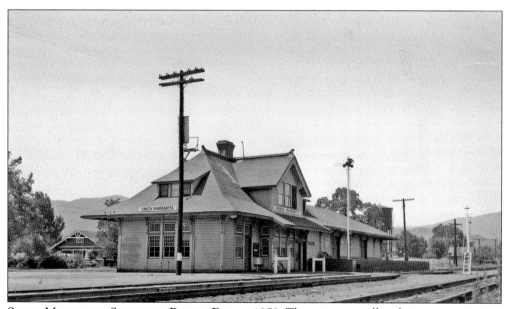

SANTA MARGARITA SOUTHERN PACIFIC DEPOT, 1953. The train was still making passenger stops and delivering the mail. One of the main duties of the town constable was to collect the mail from the train and deliver it to the post office at El Camino Real and Encina Street, about two blocks away. (SMHS.)

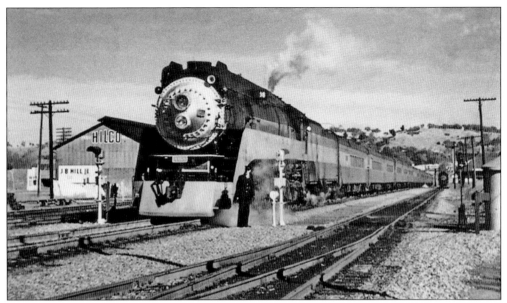

J.B. Hill Company. This photograph, with the J.B. Hill Company warehouse on the left, was taken between 1950 and 1957. The train is the Southern Pacific *Daylight*, an express that ran from San Francisco to Los Angeles. The Union Pacific Railroad merged with the Southern Pacific Railroad on September 11, 1996, forming the largest railroad in the United States. (SMHS.)

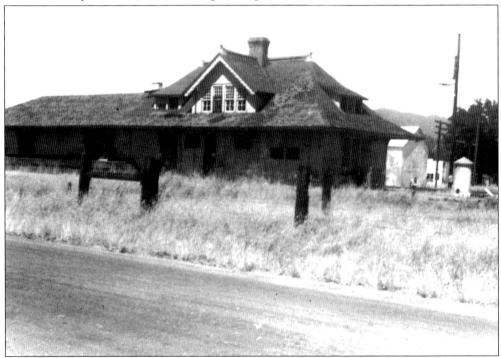

The Depot is Abandoned. By 1961, the Santa Margarita Southern Pacific Depot was abandoned and had fallen into disrepair. It was torn down in the mid-1960s. The small conical structure on the right was the telephone room. It was moved to a resident's yard. Today, this area is a fenced-off lot in the middle of town and is still owned by Union Pacific Railroad. (SMHS.)

Four

SCHOOL DAYS

Before 1850, there were no organized schools in San Luis Obispo County. Children were taught by their parents if their parents could read and write. If the family had the money, they may have been taught by private tutors. Some children may have received their education from the padres at Mission San Luis Obispo de Tolosa or at Mission San Miguel.

The Santa Margarita School was formed in 1888 as the Tassajara School District. The first classes were held in the printer's office on H Street, between Murphy and Yerba Buena Streets. In 1891, the voters of Santa Margarita assessed themselves $4,000 for a permanent school. The school was finally opened in 1893. The large one-room school was built near the same site as the current school at the end of H Street near Estrada Street. The first year, there were 35 students attending first to eighth grades. Boys and girls sat on opposite sides of the room and used separate entrances. Students who wished to attend high school had to travel by train 15 miles north to Paso Robles.

The county school board granted the residents' petition to rename the district Santa Margarita District in 1897. The single-room schoolhouse was limited in its usefulness for multiple classes. In less than 20 years, the town outgrew this schoolhouse, and in 1916, it was torn down and a modern school was erected.

By 1916, Santa Margarita had entered a new era. People were ready for a change from the old ways. E.G. Lewis had begun his Atascadero Colony eight miles to the north on the Henry Ranch, formerly the Mexican land grant Rancho Atascadero. Lewis brought to the area a vision of "new spirit." A new school, designed by Atascadero Colony architects, included an auditorium with a stage and dressing rooms.

The beautiful 1916 school was demolished in 1952 due to structural concerns related to earthquakes. In 1963, the Santa Margarita School District was combined with the Atascadero Unified School District. The present school was built with eight classrooms and a cafeteria. Today, the elementary school educates children from kindergarten to sixth grade. Students continue their education in Atascadero.

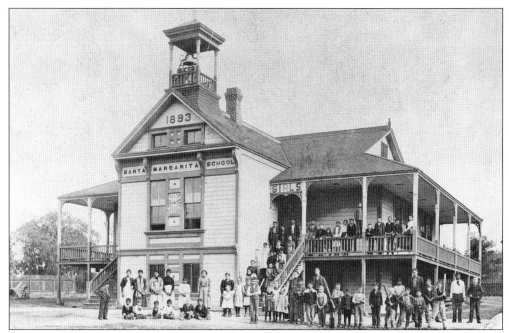

FIRST PERMANENT SCHOOL. In 1891, the voters of Santa Margarita determined that they would assess themselves $4,000 for a permanent school. The population was equally divided on where to put the new schoolhouse. Some residents wanted an elevated site for the building. Others wanted to place the building near the Yerba Buena Creek. This one-room school, which the San Luis Obispo *Tribune* called "the finest school house in the county" at the time, was situated on the elevated site near the present school. This photograph was taken around 1905. Although this school looks large, the one room limited it for multiple classes. It was torn down in 1916 when a new school was built on the same site. (SMHS.)

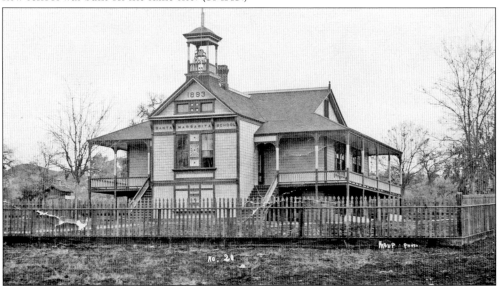

ONE-ROOM SCHOOL. The bell from this schoolhouse is now displayed near the entrance to the present school as a tribute to a student. Stone walls around the tennis court and stone benches are still visible near the original school site. (SMHS.)

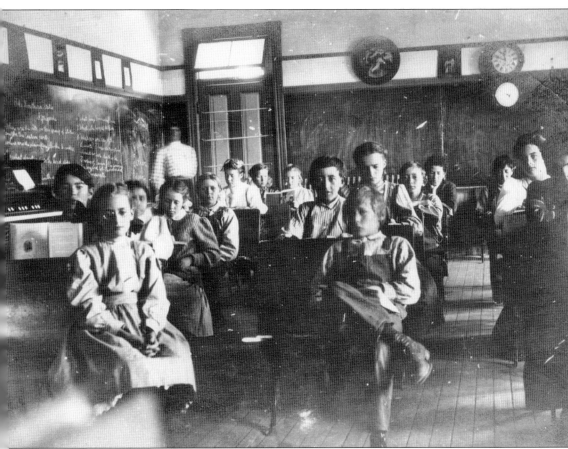

INSIDE A CLASSROOM. A notation on this photograph reads, "Miss Murdock. French lady. Teacher." The students in this class are Edna Byer, Esther Harrington, May Fenn, Tina Treaugo, Edwina Black, Adolph Estrada, Frederick Bonilla, Mary Nugent, Ray Epperly, John Costa, Christina Brown, William "Willie" Epperly, Donald Miller, Minnie Castillo, Frances Sumner, Chester Villa, and Lydia Remick. These children represent many of the old families of Santa Margarita. Edwina Black's father was Edward Black, superintendent of the Santa Margarita Ranch. Christina Brown's father was Nicholas Brown, the blacksmith. Edna Byer's father was Louis Buyer, who had the general store then. Adolph Estrada was the son of Belisario Estrada and a descendant of Joaquin Estrada. Frances Sumner was the daughter of George Sumner, who was brother of Constable Penn Sumner. Other children's parents were ranchers, farmers, and general laborers. Many of these families still have descendants living in Santa Margarita. (SMHS.)

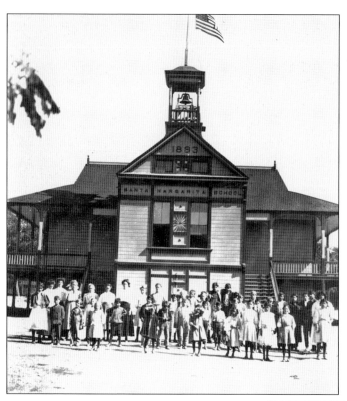

STUDENTS, EARLY 1900S. Many of the students were children of shopkeepers, blacksmiths, and restaurant and hotel workers who serviced the Southern Pacific and travelers on El Camino Real. Some students came from the outlying farms, ranches, and dairies. Although some of the work in town was transient, many of the Santa Margarita Ranch laborers and Southern Pacific Railroad workers kept their families with them. As Santa Margarita grew, many families stayed on, built houses, and put down roots. Other families moved away to pursue work elsewhere. (SMHS.)

STUDENTS, C. 1901. Pictured from left to right are (first row) Alta Knight, Henry Robertson, Rodolpho Estrada, Salina Buelna, Mina Castillo, and Lupe Flores; (second row) Arthur Barba, Hernando Trejo, Esther Harrington, Belle Halloway, Elizabeth Osgood, and Mary Benson. Names listed on the back of the photograph for the remaining students are Tita Trejo, Nora Cassilla, Lydia Remick, Edna Byer, Harold Craghill, Bessie Cassilla, Marceleno Cassilla, Bill Epperly, Frank Trejo, Frank Epperly, Henry Osgood, Bernard Epperly, Ramon Bonilla, Alma Harrington, Irene Barba, Ed Epperly, Jack Harrington, Creed Halloway, Bessie Halloway, Nellie Robertson, George Byers, Arthur Epperly, Cristina Brown, Marvin Craghill, Verta Knight, Lila Epperly, Eddie Craghill, Lena Epperly, Leta Knight, Anna Robertson, and Callie Robertson. There is one person unidentified. (SMHS.)

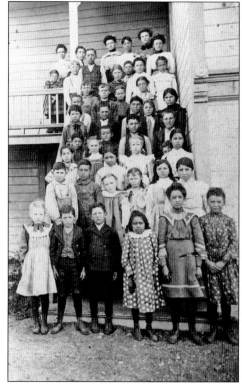

NEW SCHOOL. This school, designed by Atascadero Colony architects, was built in 1916. The auditorium sat 300 people and was fitted with movable and collapsible opera seats that could be taken out to clear the floor for social functions. Opening off the passage are the teachers' rooms and principal's office. The building was fitted with electric lights that were shaded with ground glass. The $16,000 cost of the school was paid entirely by the residents of Santa Margarita. The 1916 school, torn down in 1952, is still called the "New School" by old timers. (SMHS.)

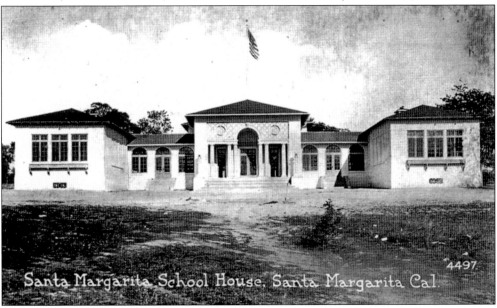

1916 SCHOOL, MODERN IN EVERY WAY. On either side of the passageways from the front hall are a cloakroom, a janitor's closet, and a storage room. According to the 1916 *Atascadero News*, the lavatories, located directly off the front hall, were "well-lit and modernly equipped." This placement allowed for privacy while "providing the maximum degree of supervision and thus both moral and physical cleanliness." (SMHS.)

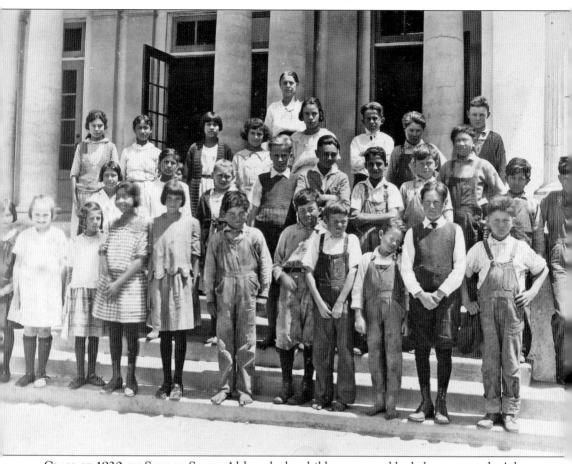

CLASS OF 1930 ON SCHOOL STEPS. Although the children are scrubbed clean, many don't have shoes. The Great Depression was especially hard on little towns like Santa Margarita. Farming and ranching profits were low or nonexistent, so the store merchants extended credit until most of them went out of business. Freight shipping was curtailed, so many railroad workers lost their jobs. Pictured among these children are Ray Pacheco, Joe Higuera, and Frank Pacheco. (SMHS.)

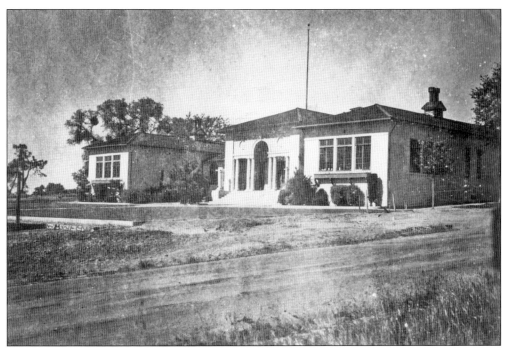

SANTA MARGARITA BASKETBALL TEAM. Santa Margarita School (above) had tennis courts, baseball fields, and basketball courts. The 1933–1934 basketball team below includes, from left to right, (first row) Warren Ball and Jack Harrington; (second row) Frank Oster, Howard Cavanagh, Leonard Miller, and Tom Cavanagh. (Both, SMHS.)

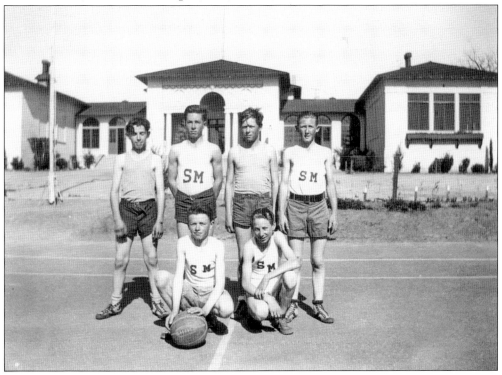

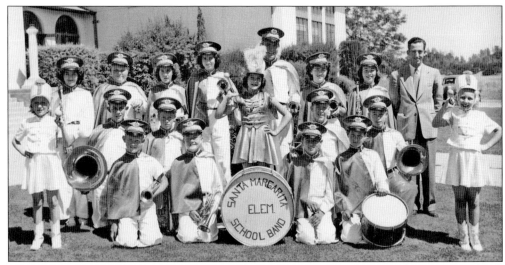

MARCHING BAND. Music was as important as sports at Santa Margarita Elementary School. Pictured here in 1949 are, from left to right, (first row) majorette Nancy Thiebaud, Dale Miller, Robert Robinson, Alfred Roza, Allen Andrews, and majorette JoAnn Meacham; (second row) Ronald Miller, Edward Thiebaud, majorette Patty Andres, Herbert Drake, and Hubert Drake; (third row) Christina Villa, Calvin Proud, Amelee Pitcher, Shirley McKelvey, Gerald Brazzi, Fern Brazzi, Polly Martin, and instructor William Baker. (SMHS.)

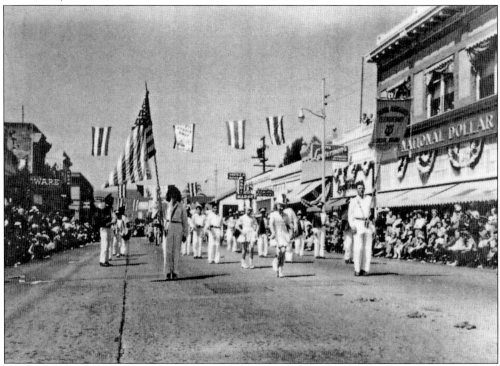

LA FIESTA PARADE IN SAN LUIS OBISPO, 1949. The Santa Margarita Elementary School marching band traveled throughout the state and won many awards. Originally, the band had only eight members; it was widely known as "the smallest marching band in California." In one parade, the band marched in place on the back of a flatbed truck. (SMHS.)

SCHOOL BUS. By 1928, many of the smaller one-room schools had been combined into the Santa Margarita School District. These schools included the Rinconda School, Tassajara School, Las Pilitas School, and Parkhill School. Bus transportation was provided for these children. Lazaro Garcia was the longtime bus driver. (SMHS.)

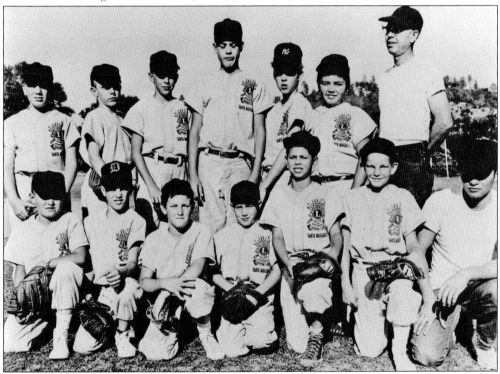

LITTLE LEAGUE BASEBALL TEAM, 1959. This team, the Tigers, was made up of boys from Santa Margarita and Pozo and was sponsored by the Santa Margarita Lions Club. A second Santa Margarita team included boys from Garden Farms. From left to right are (first row) Jimmy Blake, Don Perry, Carl Leander, Glenn Warner, Albert Estrada, Jim Doty, and assistant coach Bill Kendall; (second row) Dennis Milburn, unidentified, George Andrews, Jim Harrington, Ted Prell, Tony Elizaras, and coach Frosty Brown. (SMHS.)

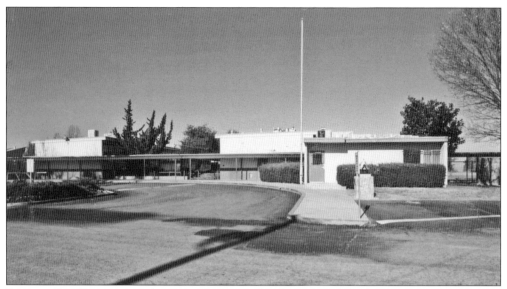

PRESENT-DAY ELEMENTARY SCHOOL. The 1916 school was demolished in 1952 due to structural concerns related to earthquakes. In 1963, the Santa Margarita School District was combined with the Atascadero School District. The present school was built with eight classrooms and a cafeteria. Today, the elementary school educates children from kindergarten to sixth grade. Students continue their education in Atascadero. (Courtesy of Jill Gallagher.)

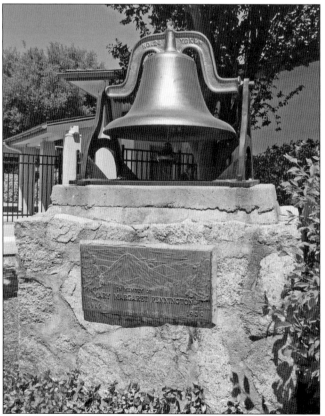

ORIGINAL SCHOOL BELL. This 1893 bell was dedicated to the memory of Mary Margaret Pennington in 1930 and placed on the edge of the playground. Her father owned B.W. Pennington's Store. Mary Margaret, 14, was at the table doing homework when a 12-year-old boy shot her from his second-floor bedroom at the Eureka Hotel. The bell and rock base were moved by the Santa Margarita Lions Club to the school's entrance in 1985. (Courtesy of Jill Gallagher.)

Five

THE TOWN OF SANTA MARGARITA

Santa Margarita was established when the Southern Pacific Railroad extended its tracks from Templeton to Santa Margarita. Patrick Murphy saw an opportunity and sold lots from his Santa Margarita Rancho lands. With the coming of the railroad, there was a need for hotels and restaurants to serve the train passengers as well as housing for the railroad employees. The Hotel Margarita and later the Eureka Hotel offered accommodations and meals. Businesses were opened to support the needs of the growing population. There were general stores that sold everything from food and clothing to ranching supplies and everyday necessities. There were stables, blacksmiths, barbers, realtors, candy and ice cream parlors, and the inevitable taverns, saloons, and dance halls. Over the years, these businesses changed hands, new businesses opened, and many closed.

A downturn in the economy came when the railroad was completed to San Luis Obispo and activity at the Santa Margarita terminal decreased. However, the dirt highway continued to run through Santa Margarita, and the town remained a stopover for people traveling up and down California. The Cuesta Grade to the south was a treacherous stretch of road and many people stopped in Santa Margarita after coming over it to rest, change horses, and often to get repairs on wagons and buggies.

When automobiles became popular, the town saw another time of prosperity. The Cuesta Grade remained treacherous, and blacksmith shops in Santa Margarita added auto repair to their services, while gas pumps were added to several of the stores. In 1914, the paving of the highway through town began and the town promoted keeping the streets and storefronts clean to make it attractive for those traveling through. Garages and a motel were opened.

In 1957, the state built a new highway system, with the highway bypassing Santa Margarita. This resulted in a drastic downturn for the community, with many businesses closing. Today, traffic on El Camino Real is primarily local residents, although the surrounding country roads are popular with bicyclists, motorcyclists, and sightseers, who often stop for a meal. The businesses that remain today support the small population of the town and outlying areas.

The town has not grown in area since the original lots were laid out in 1889. The strong community spirit that got many through the down times is just as strong today.

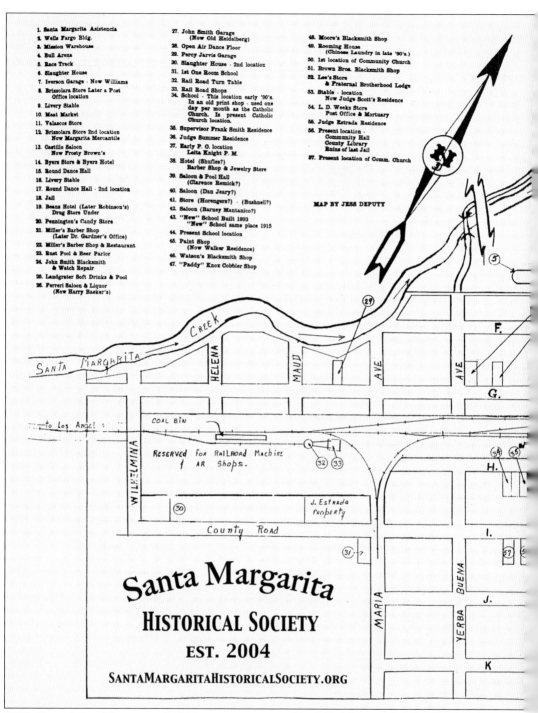

1889 Town Map. The original 1889 map was surveyed by L.D. Norton. Santa Margarita was surveyed into streets, alleys, blocks, and lots, the lots being 25 feet wide and 150 feet in length and 32 to a block. The Southern Pacific Railroad numbered its tracks and used letters for street names. Most streets were named for people: Estrada Street was named for Joaquin Estrada, first owner of the Santa Margarita Ranch; Murphy Street was named for the Murphy family; Maria

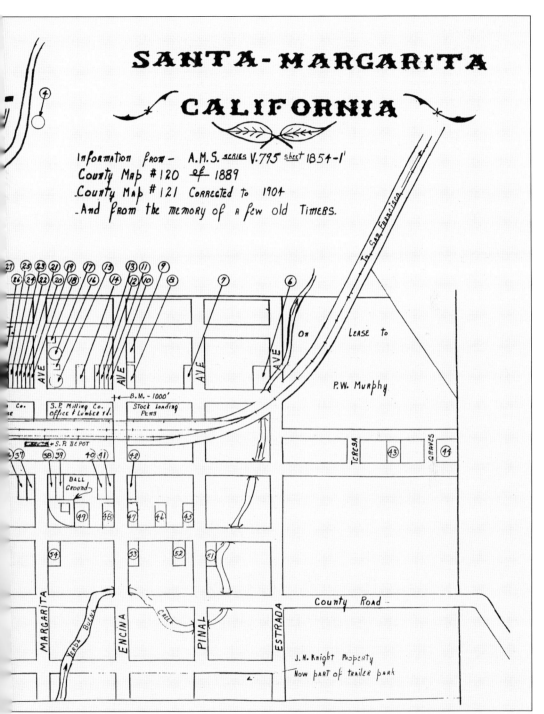

was named for Patrick Murphy's mother; Maude, Helena, Teresa, and Wilhelmina Streets were named for Patrick Murphy's nieces. Yerba Buena Street borrows the Spanish words for the plant that grew in the creek, Pinal Street is named for a stand of pine trees, and Encina Street is named for the live oak trees that populate the town. This map was updated by Jess Deputy in the 1950s to include landmarks based on the memories of a few old-timers. (SMHS.)

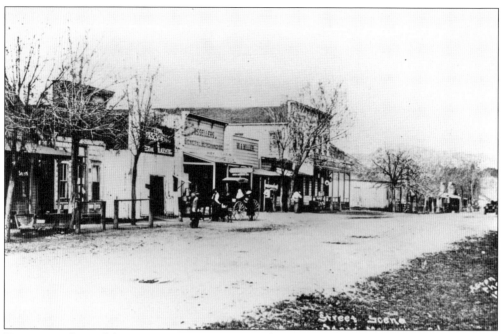

DOWNTOWN SANTA MARGARITA LOOKING NORTH. These turn-of-the-20th-century postcards show downtown businesses along El Camino Real. The two-story building is the Hotel Margarita. The round dance hall is shown across Margarita Street. This block is between Margarita Street and Murphy Street on the west side of El Camino Real. (SMHS.)

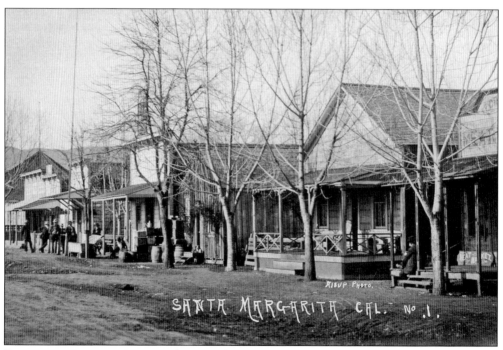

DOWNTOWN LOOKING SOUTH. This view looks south from Encina Street to Margarita Street. Velasco's Meat Market is at the far right, and the round dance hall is at the far left. (SMHS.)

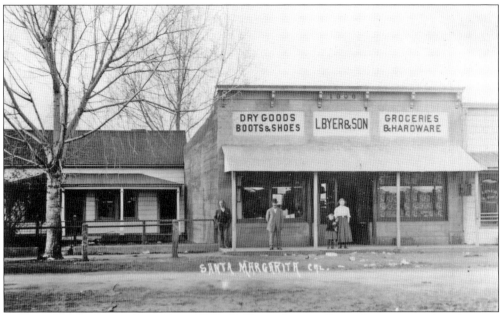

L. Byer & Son Store. Louis Byer (1852–1940) was born in Demark, immigrated to America in 1872, and was naturalized in 1880. This general merchandise store was on El Camino Real between Encina and Margarita Streets, between the round dance hall and the Brizzolara Store. Louis and Ida Byer's child, Edna, married Claude Arnold. Later, this would be the site of the Arnold Store. (Courtesy of Michael J. Semas.)

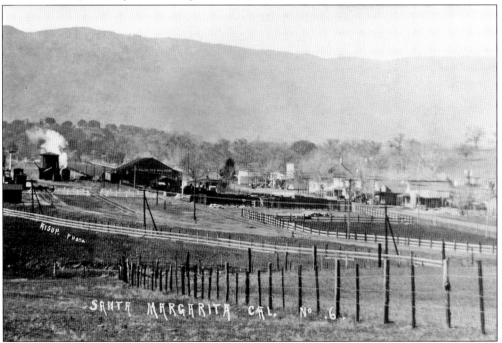

View from the Schoolyard. This view looks south from the school towards Santa Margarita and the main highway, El Camino Real. The water tank for the steam locomotives is on the left, and the corrals are in the foreground. (SMHS.)

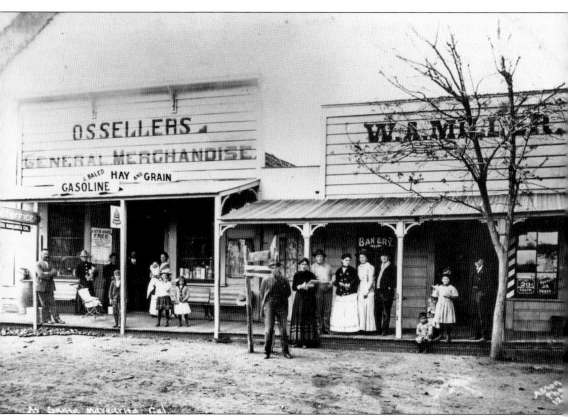

O.S. Sellers, General Merchandise. The O.S. Sellers store was originally the L. Zolezzi cash store, followed by the L.B. Kendall general merchandise store. It was acquired by Oliver Sheridan Sellers about 1908 when he also became postmaster. He owned the store at least through 1918, when he moved to San Luis Obispo. During this time, he was also a real estate agent managing the Santa Margarita Land Co. and later doing business as the Pioneer Land Company (page 90). Sellers was elected county recorder in 1920. Over the years, signage was added to the outside of the store. In this photograph, the post office sign can be seen, along with other signs advertising gasoline for sale and a telephone in the building. The W.A. Miller building next door housed a restaurant and barber shop. (SMHS.)

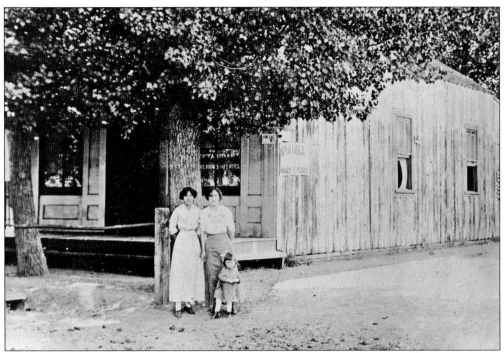

Mrs. Alva's Boarding House. Dolores deAlba (also called Mrs. Alva) let rooms for respectable women in her restaurant and boarding house. As a railroad, rancher, and cattleman's town on the highway, Santa Margarita had a reputation for rough and rowdy behavior. Mrs. Alva's Boarding House provided safe and quiet rooms away from the railroad depot and the center of town. Residents included unmarried school teachers and visiting relatives. (Both, SMHS.)

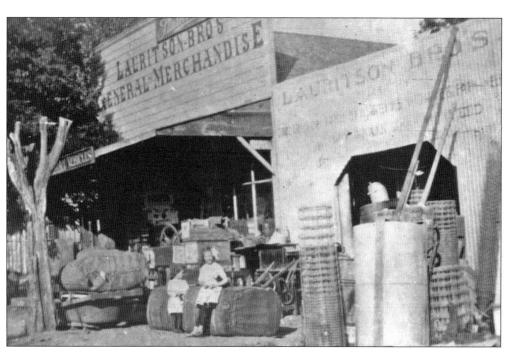

LAURITSON BROTHERS GENERAL MERCHANDISE STORE. This general store was located across the street from the depot on the corner of Encina and H Streets. Santa Margarita was the largest town for provisions for the eastern ranching communities of Pozo, La Panza, and Carrizo Plain. Ranchers would mail their order to the store and pick it up in wagons. Provisions would sometimes have to last more than a month and feed from 30 to 50 hungry men at harvest time. Owned by Tom and Lizzie Lauritson, this store also sold seed, fencing wire, nails, and road-building equipment, in addition to groceries, fabric, and candy. Lauritson sold Studebaker buggies before Studebaker made cars. Goods arriving by train could be off-loaded and stored for pickup next time the rancher was in town. This store was demolished in the 1940s. (Both, SMHS.)

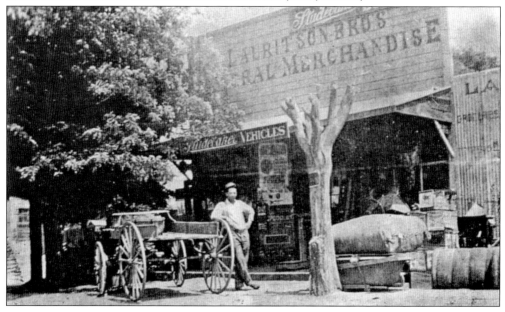

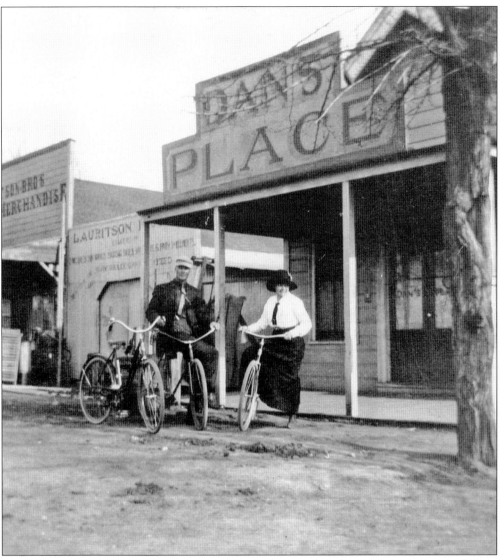

DAN'S PLACE. Daniel Drew Yeary, owner of Dan's Place, and Katharine Painter pose in 1912 in front of Dan's Place. This saloon was next to the Lauritson Brothers store on H Street across from the Southern Pacific depot. Dan Yeary remained a fixture in town and later lived in the rooms behind the Old Heidelberg Restaurant. (SMHS.)

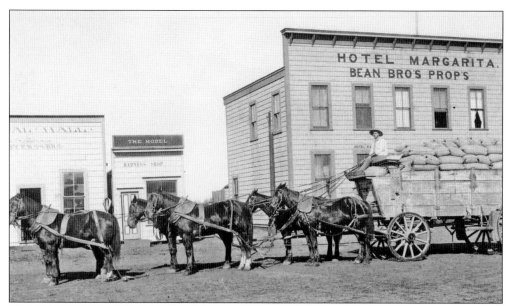

HOTEL MARGARITA. The Hotel Margarita was built by the Bean brothers for the April 20, 1889, arrival of the Southern Pacific Railroad. Once the decision was made to take the Southern Pacific Railroad inland to Santa Margarita and over the Cuesta Grade, Ruben Martin Bean and Edward P. Bean saw the need for a first-rate hotel in the new railroad town. The opulent lobby featured a restaurant and ice cream counter. The Hotel Margarita was located on the corner of El Camino Real and Margarita Street. (Above, HCSLOC; below, SMHS.)

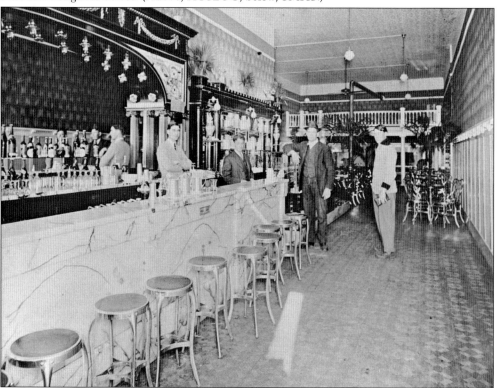

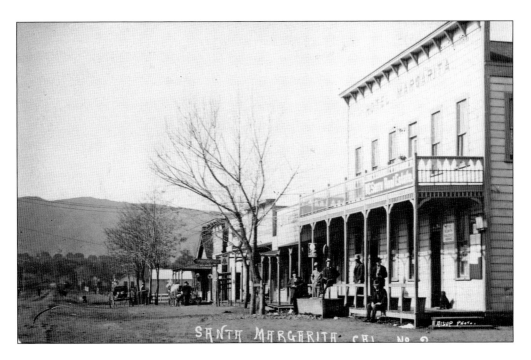

BEAN BROTHERS' HOTEL MARGARITA. In 1889, the *Santa Margarita Times* advertised the Hotel Margarita as having "good beds and good meals, 25 cents." The advertisement further stated that the Bean brothers were well known, having operated the Bean Station (the Eight Mile House on the Cuesta Grade) for 15 years. These images show the hotel after 1912, when R.W. Robertson added the veranda. Later, the Hotel Margarita was a rough establishment that saw more than its share of robberies and shootings. (Above, HCSLOC; below, SMHS.)

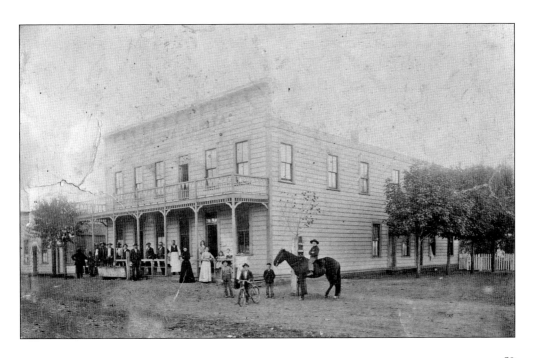

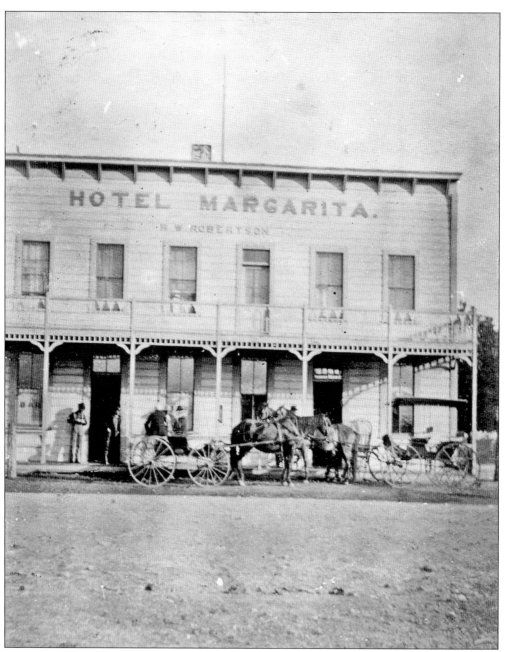

R.W. Robertson's Hotel Margarita. The Bean brothers may have been unhappy operating a hotel in a railroad boom town, or possibly they saw an opportunity to sell out before the railroad completed the tracks into San Luis Obispo. By 1900, Risdom W. Robertson from San Miguel bought the Hotel Margarita. His first order of business was to renovate the hotel throughout. Improvements included adding a veranda in front of the hotel and a ladies' sitting room upstairs. Robertson made some changes in the dining room and the bar room, changing the latter into an office. The bar room was moved opposite the old location. Unfortunately, R.W. Robertson died in 1916 at 56 years old. From 1916 to 1936, his widow, Julie Robertson, was the proprietor with help from her daughter Callie Robertson. (SMHS.)

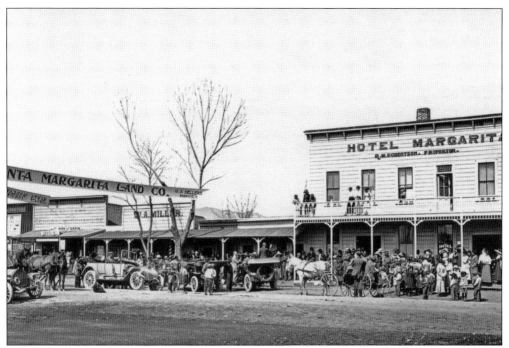

GARDEN FARMS LOTS ARE AUCTIONED. Atascadero founder E.G. Lewis announced that he planned to add the Santa Margarita Ranch to his holdings. In an article in the *Atascadero News* on August 30, 1918, Lewis stated that he was "taking over the first parcel of the Santa Margarita ranch under its contract for purchase." The purchase price for the entire ranch, according to Lewis, was $1.2 million. These photographs are of the auction for the first parcels to be sold, at what is today Garden Farms, two miles north of Santa Margarita. This was the only section Lewis was able to purchase. Lewis is in the back of the car, conducting the auction. Santa Margarita Land & Cattle was the real estate company for Santa Margarita Ranch, owned by the Reis family and managed by O.S. Sellers. (Both, SMHS.)

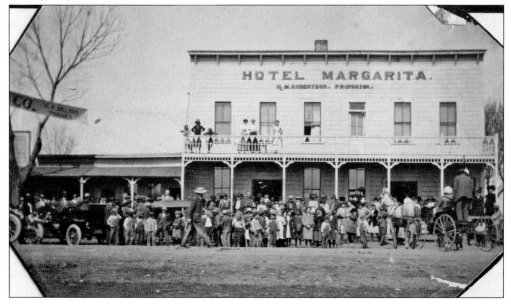

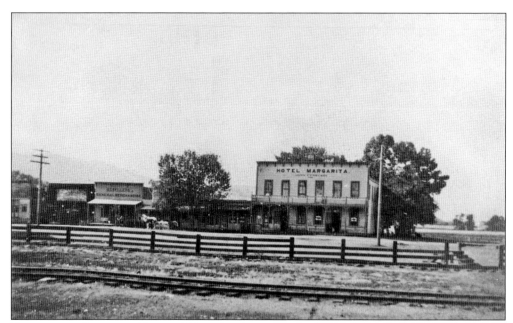

ELECTRICITY COMES TO TOWN. Although telegraph service arrived with the Southern Pacific Railroad in 1889 and telephone service arrived in 1902, it wasn't until December 1912 that the Hotel Margarita was wired for electricity. In 1921, a wireless radio antenna was installed on the hotel roof to aid the Union Oil pumping station workers at Garden Farms to communicate with the striking oil workers in Maricopa. John Ferguson was the Hotel Margarita proprietor. (SMHS.)

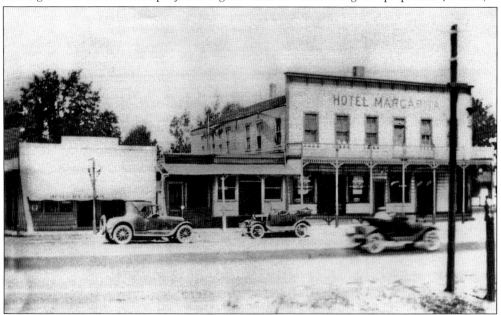

FIRE AT THE HOTEL MARGARITA. A second-story fire in the old wooden building during the Depression spelled the end of the once-glorious hotel. Santa Margarita has always had a small volunteer fire department. The current fire department, located on El Camino Real between Encina and Margarita Streets, will soon be replaced by a new fire station on the lot of the former Hotel Margarita. (SMHS.)

ROUND DANCE HALL. Originally, this round dance hall was at the Bean brothers' Eight Mile House on the Cuesta Grade. When the brothers built the Hotel Margarita, they disassembled their dance hall and reassembled it across the street from the hotel at El Camino Real and Margarita Street. Later, it was used as a stable before it was disassembled again and the wood used in other buildings. (SMHS.)

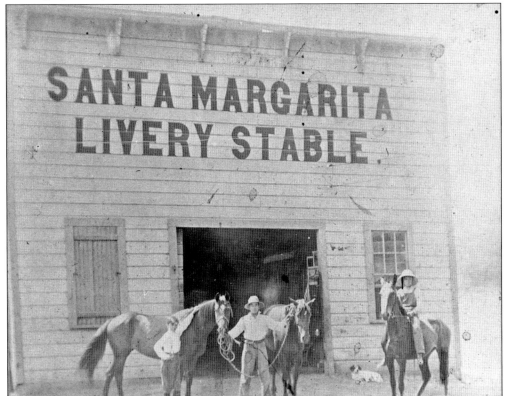

SANTA MARGARITA LIVERY STABLE. The livery stable was located one block west of El Camino Real at Encina and F Streets. Bob Garcia is on the horse. (SMHS.)

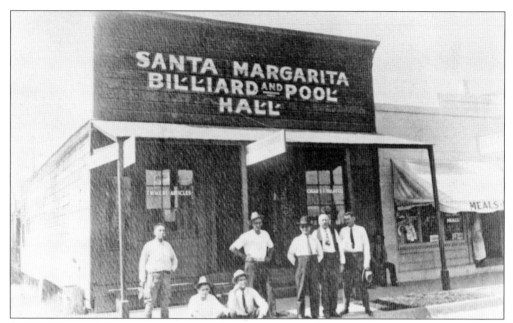

SANTA MARGARITA BILLIARD AND POOL HALL. The pool hall was owned by Domingo A. Ferrari and was located in the middle of the block between Margarita and Murphy Streets on El Camino Real. Pictured here are, from left to right, Victor Torres, Dan Yeary, unidentified, D.A. Ferrari, and unidentified. The W.A. Miller Restaurant is to the right. (SMHS.)

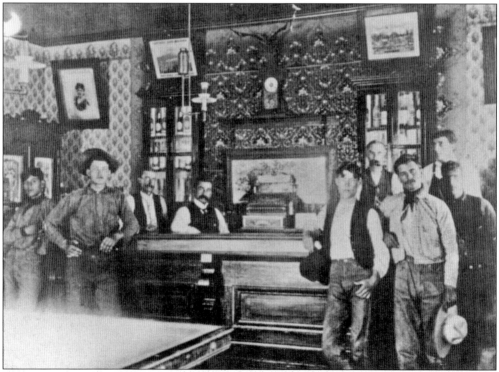

INTERIOR OF THE POOL HALL AND D.A. FERRARI BAR. The pool hall doubled as a saloon, called the D.A. Ferrari Bar, and was popular with railroad workers, ranchers, and locals.

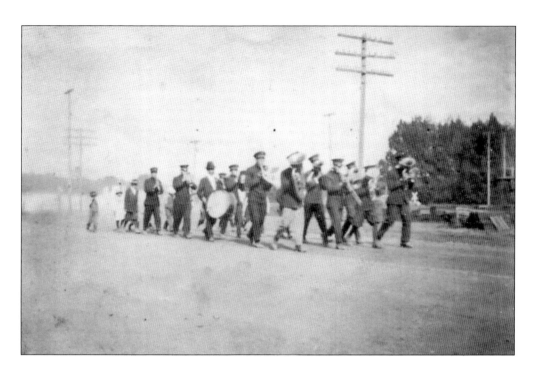

SANTA MARGARITA BRASS BAND. The Santa Margarita brass band played in the county parades and was the most popular music for all the parties in town. This brass band even performed at baseball games. Below, Justice of the Peace Alberto Estrada is behind the bass drum, and barber Dave Miller is standing second from the right. Note that the drum has a hole in it. The photograph above was taken in 1917. (Both, courtesy of Charlene Miller Edwards.)

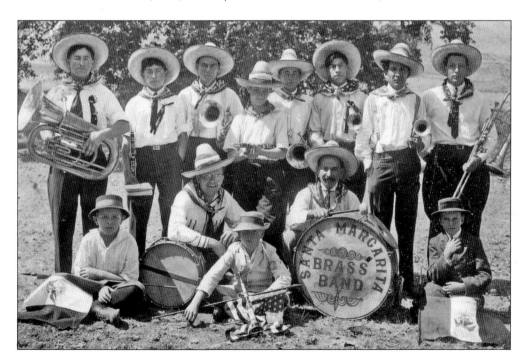

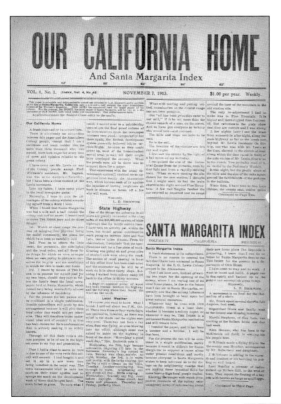

OUR CALIFORNIA HOME AND SANTA MARGARITA INDEX. The first local newspaper was the short-lived *Santa Margarita Times*. It was published weekly in 1890 in a small printer's shop on H Street. The second and last Santa Margarita newspaper was printed from 1913 to 1914. *Our California Home and Santa Margarita Index* was published weekly by L.D. Beckwith. Much of the newspaper was used to extol the progress of Atascadero, the newest community, eight miles north of Santa Margarita. Advertisers included the Eureka Hotel ("One of those comfortable CEMENT buildings"); Brizzolara General Merchandise ("The Clean Store"); Margarita Ice Cream Parlor ("Fine Toilet Supplies a Specialty"); W.A. Miller Bakery ("Cigars and Tobacco"); and the Hotel Margarita ("Home Atmosphere & Home Cooking Sunday Dinner 50 cents Chicken and Ice Cream"). (SMHS.)

NEW NAME. In January 1914, the masthead was changed to *Santa Margarita Index and Our California Home*, with more emphasis on Santa Margarita news. The paper wrote about local residents, who was visiting or traveling, reports from the outlying areas, information on rainfall, and road conditions. In 1914, in anticipation of the new paved highway, the town ran a "clean" campaign to keep the streets and stores clean. Stores were assessed a fee that went into a fund to pay for a person to clean up and for a garbage can to be placed in front of each establishment. (SMHS.)

LORING DUMAS BECKWITH. L.D. Beckwith was editor and owner of several newspapers in Colorado and New Mexico before coming to Santa Margarita in 1913. Beckwith held progressive views that were reflected in his newspapers. By 1915, Beckwith had left Santa Margarita to be editor of the *Atascadero News*. In 1920, he moved to Stockton. (Courtesy of Michael J. Semas.)

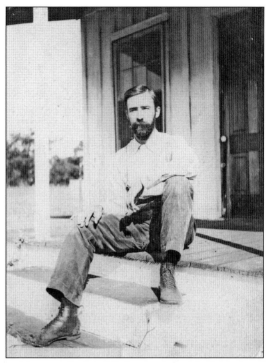

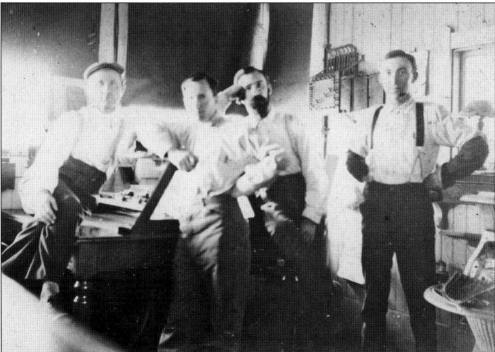

NEWSPAPER EDITOR. Beckwith (center with beard) poses with his staff at the *Our California Home and Santa Margarita Index* office on Wilhelmina Street. The paper was published only one year, from November 7, 1913, to December 25, 1914, before Beckwith moved to Atascadero to become the first editor of the *Atascadero News*. (Courtesy of Michael J. Semas.)

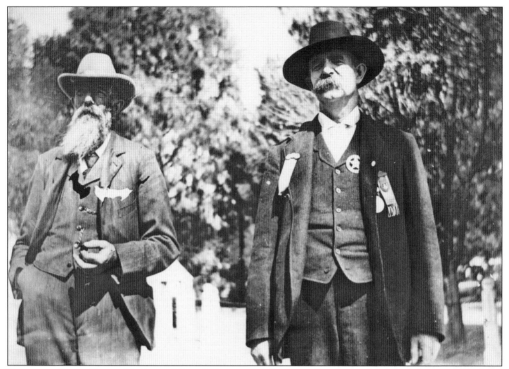

FRONTIER LAW. Constable Louis "Penn" Sumner, right, served as Santa Margarita's constable from 1923 to 1934. The constable's main duty was to act as conservator of the peace. He was paid to deliver warrants, act as court bailiff, collect fines levied by the county, and transport prisoners. The constable could appoint deputies and round up townspeople to fight wildfires. The man on the left is possibly Penn's brother George Sumner. (SMHS.)

SANTA MARGARITA JAIL. After the first jail, a redwood building on F Street, burned down in 1907, the county purchased land on Murphy Street near I Street to build a concrete jail. This jail had two small cells. Another cell and constable's office was completed in 1913 and attached to the existing jail. The structure was abandoned in the mid-1940s and fell into disrepair. In 2004, the Santa Margarita Historical Society renovated the constable's office, and it is now used as a small museum. (SMHS.)

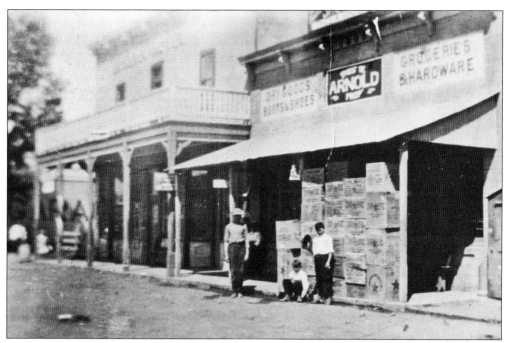

ARNOLD STORE. Thomas Arnold was the only child of Anna Sinton and James Arnold. Thomas married Margaret Josephine (JoJo) Keck in 1899. Thomas owned the Santa Margarita Chrome Mine on the Cuesta Grade before opening the Arnold Store in 1914, previously the Byer and Son Store (page 53). The Arnold Store sold boots and shoes, groceries and hardware, and other general merchandise, and was next to the Eureka Hotel. Pictured above, from left to right, are Claude, Guy, and Loyal, sons of Thomas and Josephine Arnold. Below, from left to right, are Josephine Arnold, unidentified, Thomas Arnold, and unidentified. (Both, courtesy of Barbara Arnold.)

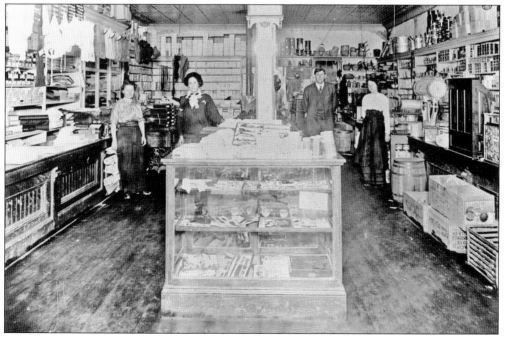

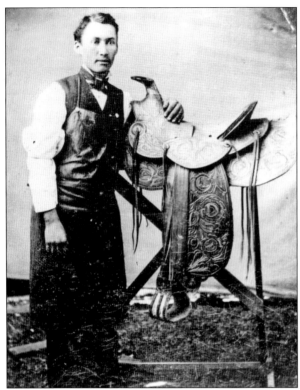

G.S. Garcia, Saddle Maker. The photograph above shows a young Guadalupe Santiago Garcia with one of the first saddles made in Santa Margarita. The stamping does not show as much fine detail work as his later saddles. A 15-year-old Garcia began his career as an apprentice at the Arana Saddle Shop in San Luis Obispo. By 1889, Santa Margarita was the largest town between San Jose and Santa Barbara, and Garcia opened his own saddle-making shop at the corner of Encina Street and El Camino Real. The location near the railroad shipping corrals was fortuitous. With full wallets, visitors' first stop before the saloon was the G.S. Garcia Saddle Shop. Garcia sensed that Santa Margarita's prosperity would change once the railroad was completed into San Luis Obispo. By November 1893, the 29-year-old Garcia and his wife, Saturnia, relocated to Elko, Nevada. (Both, courtesy of Dee Dee Garcia White.)

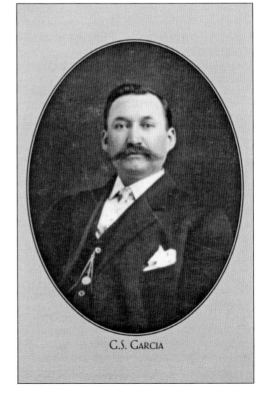

G.S. Garcia

CIRCUS. The traveling circus came to Santa Margarita on January 16, 1920. The *San Luis Obispo Daily Telegram* reported, "the most important thing in Santa Margarita today is a traveling circus. There are two cars and consist of a bear, goat, two performing dogs and a monkey, which are drawing quite a crowd of youngsters as is usual with a show of that kind." It has been reported by old-timers that the two railroad cars were unloaded at the depot and the animals walked to the ballpark at Margarita and I Streets. (Both, SMHS.)

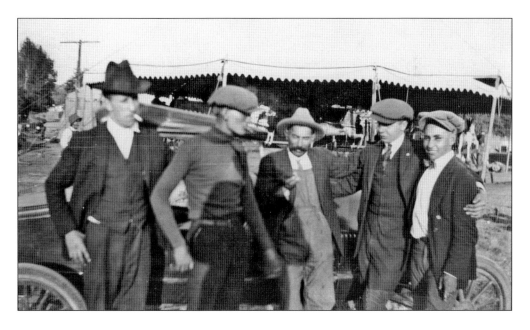

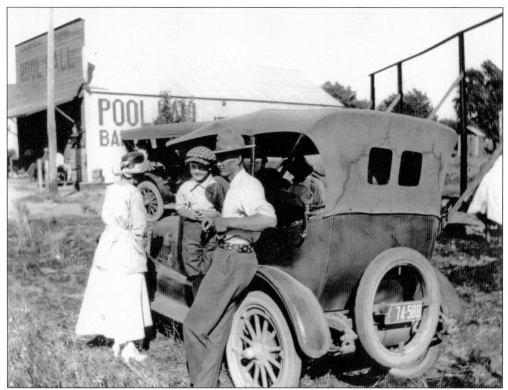

PROHIBITION. Although Prohibition and then the Great Depression hit Santa Margarita hard, the residents of town made their own fun. Ball games, birthdays, holidays, parties, weddings, and funerals were all good reasons to get together and celebrate. Often, just having kin or friends visit from out of town was a reason for a celebration. Above, the pool hall was next to the ball field. Below, Bill Epperly and friends sit in the middle of H Street. (Both, SMHS.)

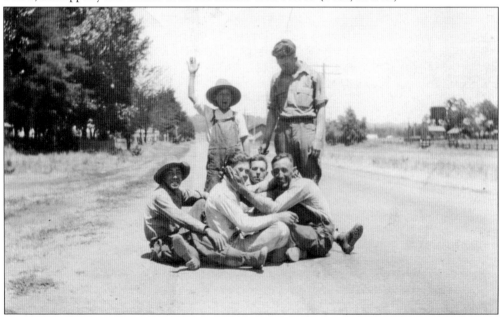

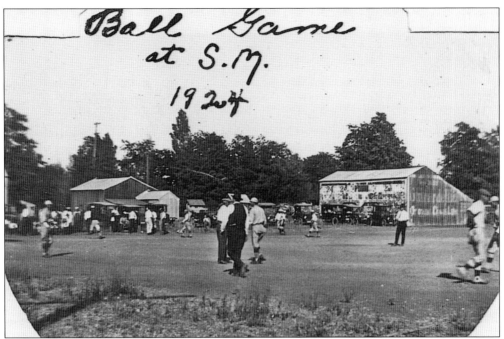

BASEBALL. In the 1920s, baseball was an important pastime in Santa Margarita. The 1921 town team below is, from left to right, Ed Epperly, William Quartermarsh, John Costa, Ed Bertinoia, Ray Epperly, Ed Pacheco, Walter Walker, Bill Epperly, and Adolph Morago. One local relates that in the 1940s, some ball games were played on the elementary school grounds in addition to the field at I and Margarita Streets. At that time, one team was comprised of men who worked on the Southern Pacific Railroad's tracks and tunnels. The other team was comprised of men who worked in town or on surrounding ranches. Some of the men who played for the Southern Pacific team were Kenneth Pharis, Ernie Estrada, Dick Stanucci, and Sam Armas. Some of the men who played for the town team were Sam Estrada (he pitched and had only one arm), Hank Tartaglia, Frosty Brown, Dave Miller, Luis Sapien, and the Baro brothers. (Both, SMHS.)

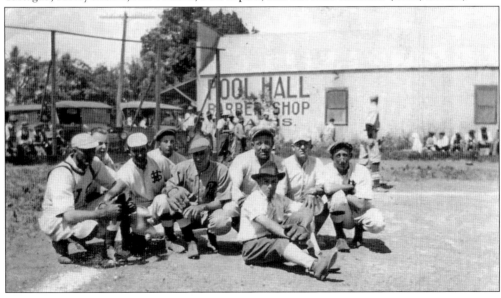

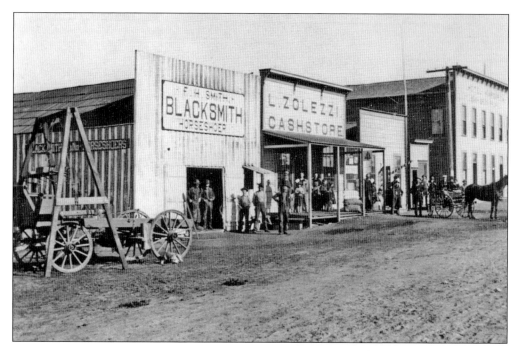

BLACKSMITHING. American blacksmith F.H. Smith and Swiss Italian shopkeeper Louis Zolezzi work side by side in the later years of the 19th century. By the early 20th century, below, horses had given way to automobiles. J.W. Smith became owner of the business, and although he still did blacksmithing, he also repaired automobiles and sold gasoline. Louis Zolezzi sold out to son-in-law Fred Brizzolara, who moved his store a block to the north. W.A. Miller had opened his restaurant. R.W. Robertson had bought the Hotel Margarita and added the veranda. (Both, SMHS.)

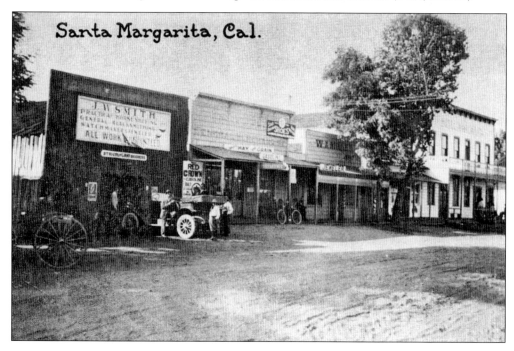

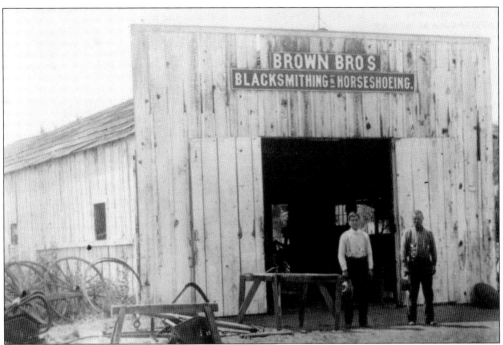

BROWN BROTHERS' BLACKSMITH SHOP. Nicholas and Aaron Brown owned and operated the blacksmith shop on the corner of Pinal and I Streets. Aaron J. Brown (left) is pictured here with friend and neighbor William Keffury. (Courtesy of Joe Brown.)

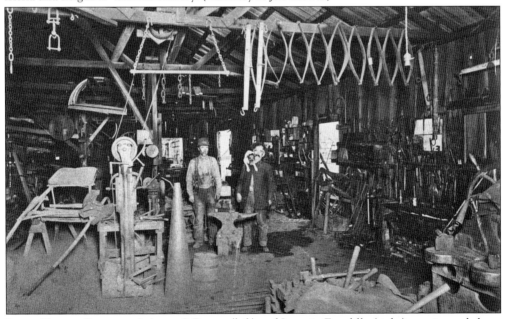

INSIDE BROWN BROTHERS'. Aaron J. Brown (left) and Joaquin Estadillo (right) are pictured about 1909. The blacksmiths were strong, hard-working men. They shoed horses and oxen, repaired wagons and wheels, engineered parts, worked with rope and leather, and made their own charcoal. Blacksmiths were crucial to keeping people and supplies moving, and they also worked as teamsters. (Courtesy of Nancy Brown Pullen.)

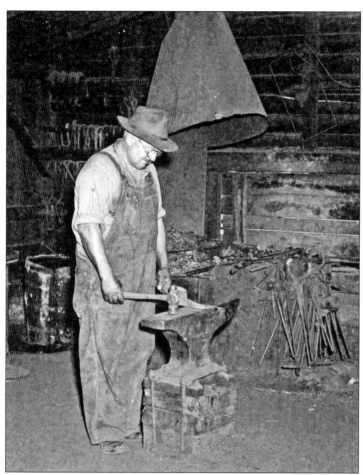

GEORGE MOORE, BLACKSMITH. This blacksmith shop was located at the corner of Encina and I Streets. As demand for blacksmith services declined, many blacksmiths augmented their incomes by shoeing horses. After automobiles became a popular mode of transportation, a blacksmith was often the only person who could fashion broken car parts in remote places such as Santa Margarita. (Both, SMHS.)

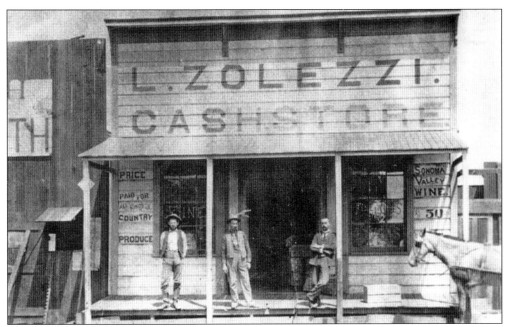

ZOLEZZI/BRIZZOLARA STORE. Louis Zolezzi owned this store when he turned it over to his daughter Josephine's husband, Fred A. Brizzolara. By 1913, F.A. Brizzolara moved his business into a larger building farther north on El Camino Real that is now the Margarita Mercantile. (SMHS.)

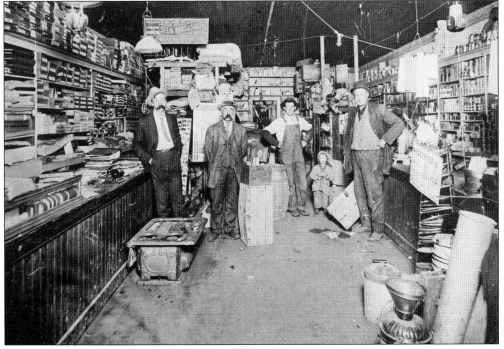

INSIDE OF BRIZZOLARA STORE. This photograph shows the interior of the Brizzolara store. A 1914 advertisement in the local newspaper refers to his establishment as "The Clean Store." Fred is in the middle in the white shirt with his hands on his hips. The current sidewalks were installed in 1926, and the Brizzolara name is still imprinted in the sidewalk in front of the store. (SMHS.)

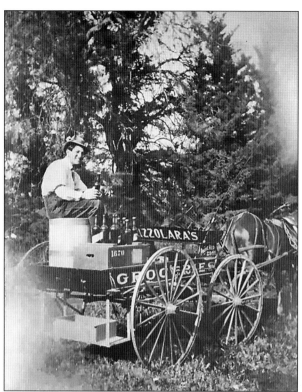

BRIZZOLARA'S DELIVERY WAGON. In 1914, William Torres of Pozo is pictured on Brizzolara's delivery wagon. The Torres family owned a general merchandise store in Pozo. (SMHS.)

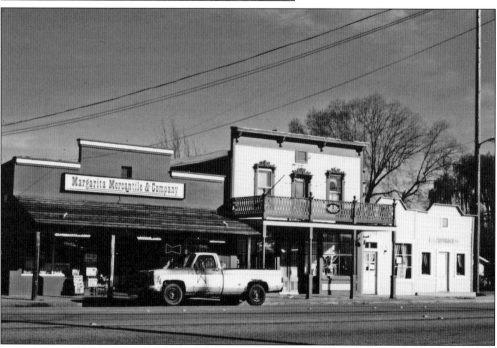

MARGARITA MERCANTILE & COMPANY. In 1976, the Margarita Mercantile was transformed from a mid-20th-century white-fronted building into an older-looking building more reminiscent of the 19th-century Western town. (SMHS.)

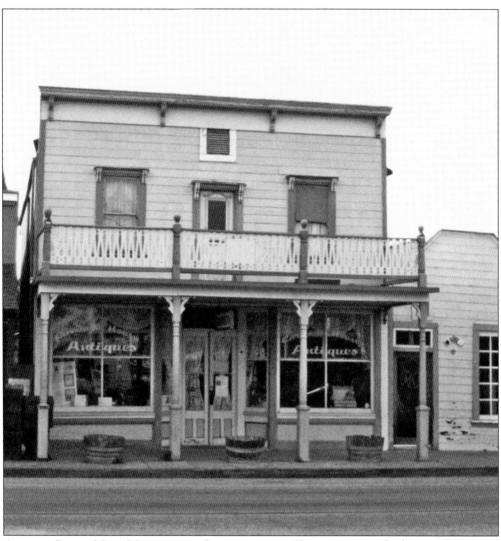

ANTIQUE STORE, MEAT MARKET, AND CONFECTIONERY. The antique store building and the Meat Market and Confectionery buildings (pages 80 and 81) were lots 1 and 2 of the original town map. From the 1920s until 1976, both lots and all three buildings were sold as a package deal to each successive owner. It wasn't until 1976 that the lots and buildings were sold individually. (SMHS.)

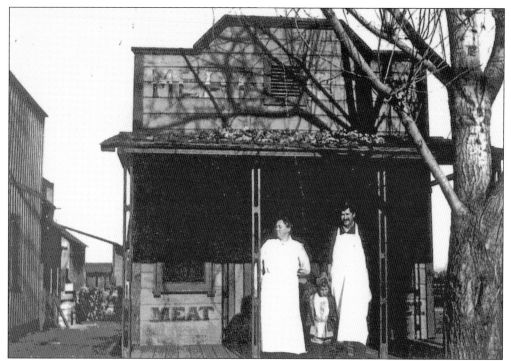

MEAT MARKET. The Meat Market building is on the corner of El Camino Real and Encina Street. The lot on which it stood was first sold in 1891 for $250. By 1904, the lot was sold to Thomas Carroll for a $10 gold coin. In 1907, future county supervisor E.W. Black purchased the lot. In this 1916 photograph, it was used as a butcher shop by John Guy. Pictured are, from left to right, Dolly Guy, Helen Guy, and John Guy, butcher. In 1921, Black sold the lot and market to John Velasco for that same $10. During Velasco's ownership, John Guy continued to operate the meat market until his death in 1936. (SMHS.)

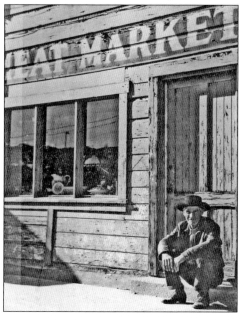

TAKING A BREAK. Harry Martin takes a break on the step of the meat market when it was Bessie Bryan's antique store. The Meat Market name remained on the building even though it was an antique store. (SMHS.)

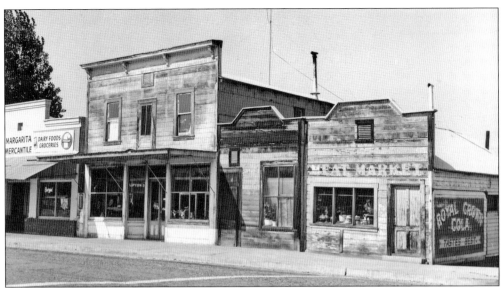

CONFECTIONERY AND MEAT MARKET. Originally, there was a gap between the antique store and the Meat Market. Sometime prior to 1926, a structure was built in the gap to match the storefront of the Meat Market. This new store became the Confectionery, an ice cream and candy store. In 1956, the land and buildings were bought by Bessie Bryan and used as an antique store until 1975. From 1975 until 1978, the building (as well as the antique store building next door) was a turn-of-the-20th-century-themed beauty parlor and antique store named Bessie's Tonsorial Parlor. After 1978, the building was empty for two decades. The two lots with three buildings were split in 1976. In 2010, the Confectionery and Meat Market buildings were completely rebuilt. The site is now a tavern. It was probably in the 1950s when the Royal Crown Cola advertisement seen on the side of the building appeared. The original Royal Crown sign was preserved and is on a side fence facing Encina Street. (Both, SMHS.)

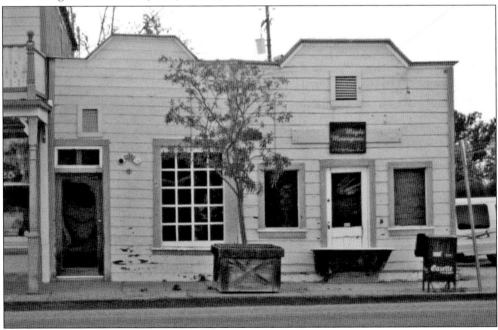

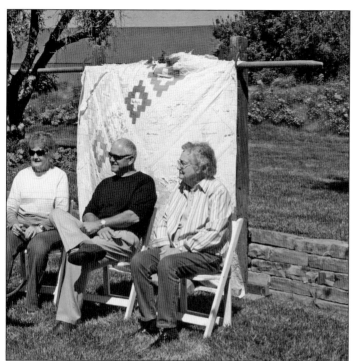

REUNION OF QUILT RELATIVES. In 2007, three people with a connection to this quilt came together at the Santa Margarita Ranch to reminisce about their relatives and the times. Bonnie Simpson (left) was four years old when her mother stitched her name. Frank Mecham (center) is the grandson of Ma Mecham and the great-great-great-grandson of Joaquin Estrada, first owner of the Santa Margarita Ranch. Lovena Doty (right) has four relatives on the quilt. (Courtesy of Jill Gallagher.)

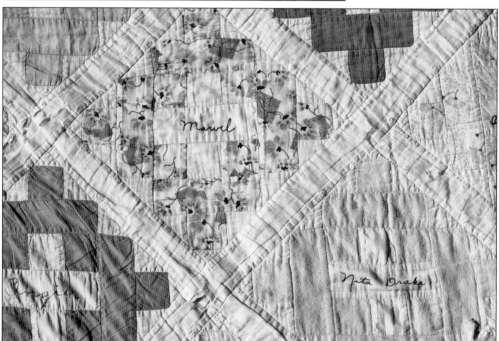

FRIENDSHIP QUILT. Marvel Haberkern moved back to Santa Margarita in 1932 after living for several years "over in the valley," as she called it. This friendship quilt was the result of a welcome-home quilting bee. Haberkern was known for her frugal tendencies. Unfortunately, the quality of the fabric she used to join the signature blocks was somewhat less than fine. Many items were made from bleached flour sacks. (SMHS.)

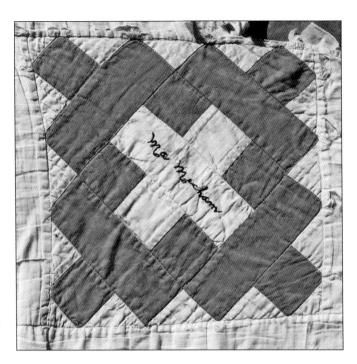

MA MECHAM. "Ma Mecham" was Cynthia Hawkins Mecham from Kansas. She was educated and originally wanted to be a doctor or lawyer; however, these options were not easily attainable for women, so she became a teacher. Cynthia married Samuel Mecham, and they moved to Santa Margarita during the Great Depression looking for better work. Samuel was a cowboy, woodcutter, and gardener. He and Cynthia were the classic "cowboy marries schoolmarm" story. Cynthia taught Sunday school for many years at the Santa Margarita Community Church. (SMHS.)

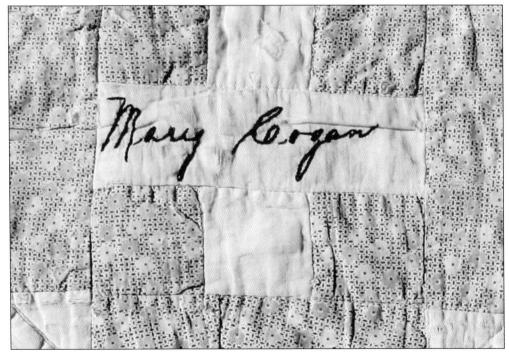

MARY COGAN. Mary Cogan was Santa Margarita's postmaster from 1922 until her retirement on July 3, 1960. Her husband, John Cogan, was the telephone agent and ran the local telephone exchange. The telephone office, post office, and library were housed together on the corner of Encina Street and El Camino Real until 1961. (SMHS.)

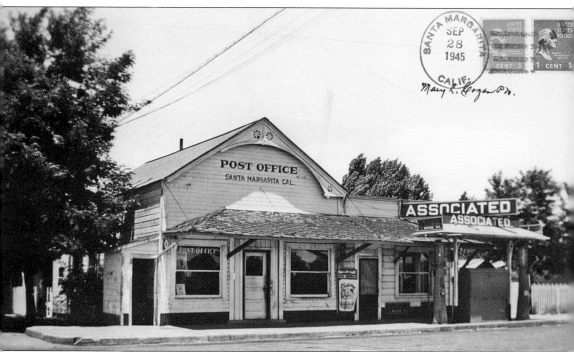

POST OFFICE. The first local post office was in operation from 1867 to 1878 at the Wells Fargo Building on the Santa Margarita Ranch. Reuben Bean was postmaster from 1878 to 1881 when the post office was closed. The post office at this time was probably at the Eight-Mile-House on the Cuesta Grade. With the arrival of the Southern Pacific Railroad, the post office reopened in January 1889 at the Hotel Margarita, again with Reuben Bean as postmaster. Successive postmasters were Mitchel W. Weeks (1890), Adolf Lowinger (1894), Young A. Lee (1896), Lewis D. Weeks (1898), Leta P. Knight (1906), Lon B. Kendall (1907), Oliver S. Sellers (1908), Amanda B. Walker (1913), Della V. Schroeder (1920), Mary L. Cogan (1922), and Mila M. Waltz (1960). Up to 1914, the majority of the postmasters were also merchants and the post office was housed in their store. In 1914, Postmaster Amanda Walker opened the post office in the building pictured here. It was located on El Camino Real and Encina Street in the former building occupied by G.S. Garcia, the saddle maker. The *Santa Margarita Index* reported that the new post office had five times the number of lock boxes as previous locations and all but three were rented before the new office opened. Amanda Walker's son Clinton also had a business in this building cleaning and pressing men's clothing. In this 1945 photograph, there is also a gas station. This building later housed the telephone company and the library. In 1961, the post office moved to its present location where the Eureka Hotel once stood. The post office serves the town of Santa Margarita and all the outlying areas. (SMHS)

LIBRARY. Santa Margarita may have had an informal library before the county established a branch in the post office at El Camino Real and Encina Street in 1924. This was a late date, but schools had libraries, and this was often sufficient for a small community. The first library, in a cupboard in the lobby of the post office, also shared space with the telephone office. In 1958, the newly appointed county librarian requested a permanent library in the recently vacated constable's house on Murphy Street between I and J Streets. This 400-square-foot library was replaced with a larger library next door in 1995. Frances Van Artsdalen (below) was Santa Margarita's librarian from 1959 until 1975. (Both, SMHS.)

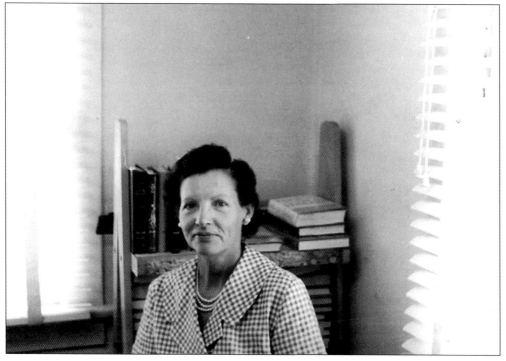

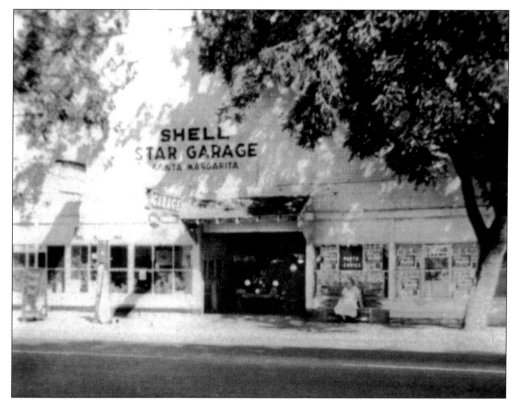

SHELL STAR GARAGE. This garage and gas station, on the corner of El Camino Real and Margarita Street, was built where the Bean brothers' round dance hall once stood. Originally Kruger's Garage from 1927 to 1938, it was sold to Grover Hampton and had a small café inside. When Claude Proud bought the garage, he sold Shell Oil gasoline and called his garage the Shell Star Garage. Hazel E. Proud is pictured here sitting outside the garage. (SMHS.)

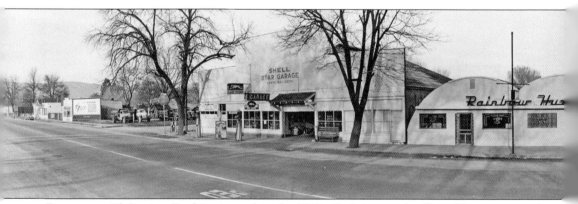

PANORAMA. El Camino Real is pictured in the 1940s. Prohibition, the Great Depression, and World War II were especially hard for Santa Margarita. Before Prohibition, workingmen frequented Santa Margarita for a good time not available on the outlying ranches and farms. Visitors and workers from the railroad patronized both hotels and saloons. Since local families owned bars and saloons, the lead-up to Prohibition was hotly contested in Santa Margarita. More than 90 percent of townspeople voted against a law regulating liquor licenses, which was a precursor to

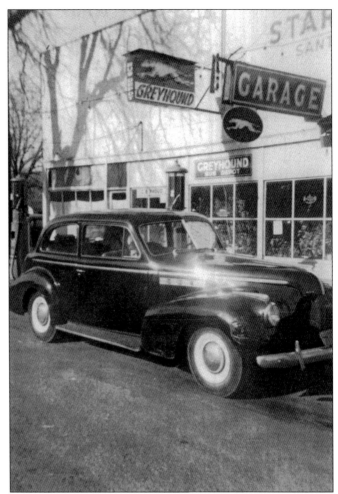

PROUD'S GARAGE. Gasoline was hand pumped into a measured glass jar atop the pump and then gravity fed. After Pickwick Stage Lines merged with Greyhound Lines in 1928, Proud's Garage doubled as the bus station. In the late 1970s, the garage was converted into an antiques auction site. The original building still stands and is now an antiques mall. (SMHS.)

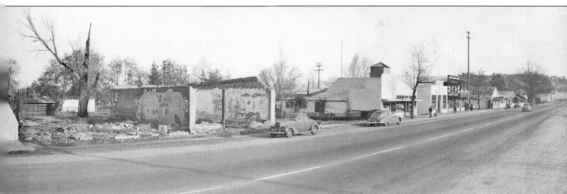

Prohibition. The Depression meant fewer freight trains and fewer railroad workers renting houses and using the markets. Falling cattle prices meant fewer cowboys bringing cattle to the railhead. After World War II, many young men left Santa Margarita seeking better job opportunities elsewhere. The demolished building seen here right of center was the Eureka Hotel. Some of these buildings survive today. (SMHS.)

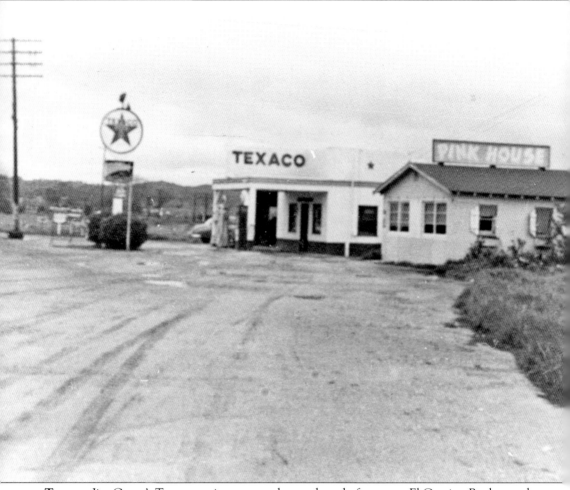

TEXACO. Jim Green's Texaco station was on the south end of town on El Camino Real near the entrance to the road to San Luis Obispo. The opening of San Luis Obispo's newest recreational lake, Santa Margarita Lake, in 1968 gave life to a small fishing supply industry. Most gas stations sold bait, and some sold fishing boats and outboard motors. The Pink House, also called Green's Nut House, was owned by Jim Green's mother-in-law, Hazel C. Avery. She sold small gift items, fruits, and nuts from her store to passing travelers. Later, the station was owned by John May and then Bob Doty. It was torn down in 1979. (SMHS.)

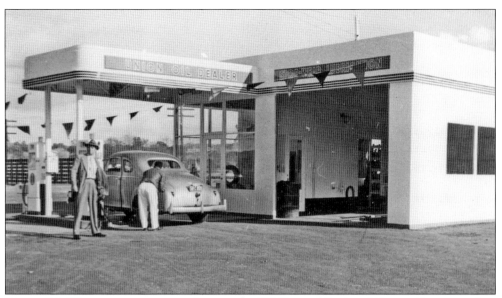

UNION 76. The service station on the corner of El Camino Real and Encina Street was first owned and operated as a Union 76 station by Abe Keffury. Later, Keffury leased the station to Vern Stewart from 1959 until 1961. Chris Pintor and his son, also named Chris Pintor, bought the business in 1988, but in 1990, when new federal laws required vapor recovery pumps, the last gas station in town at that time closed. In 1991, new pumps were installed, and the station reopened. Pintor's Tire and Wheel is the only gas station in Santa Margarita and, for those traveling east, the last gas for 87 miles. (Both, SMHS.)

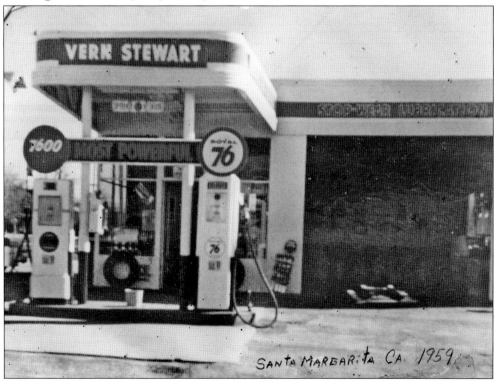

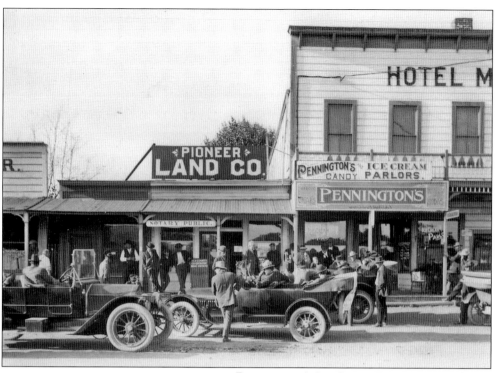

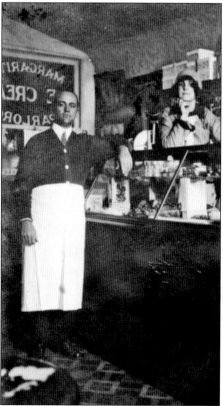

PENNINGTON'S ICE CREAM PARLOR. Bernard W. Pennington opened his Margarita Ice Cream Parlor in 1913 in what was the lobby and dining room of the Hotel Margarita. Ice cream and candy became popular treats during the first half of the 20th century, because a person of any age could get some real pleasure for not much money. At left are B.W. and Mayme Pennington. The Pioneer Land Company was managed by O.S. Sellers, who was also a notary public. Sellers was still operating his general merchandise store just down the street. (Both, courtesy of Carol Triplet.)

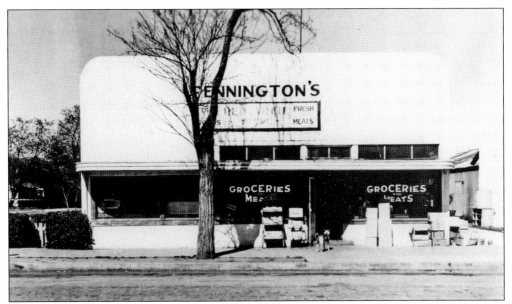

RED AND WHITE STORE. Sometime after 1925, Pennington expanded his ice cream and candy empire into a food market. He moved farther north between Encina and Murphy Streets to the former location of the Castillo Saloon. Red and White Stores were a chain of independently-owned grocery stores in small towns. All of the stores had to have "Red and White Store" in their name, along with the owner's or town's name. (SMHS.)

FROSTY'S MARKET. Bernard Pennington sold his business to Forest "Frosty" and Evie Brown. Frosty kept the business until 1963. Later, the building was a True Value hardware store. It was torn down and rebuilt in 1984. Today, it is the Porch coffee shop. (SMHS.)

MARGARITA INN. The Santa Margarita Inn was built during one of the town's two boom times. While the Union Pacific Railroad was completing the line from Santa Margarita to San Luis Obispo between 1889 and 1894, the town saw its biggest boom, with railroad workers and teamsters moving freight and passengers up and down the Cuesta Grade. After the line was completed, the town went into a decline. But when people started driving automobiles on El Camino Real, Santa Margarita saw its second boom, with new "motor inns" and gas stations. After Highway 101 bypassed the town in 1957, Santa Margarita went into decline again. The Santa Margarita Inn held out until it was torn down in 2000. (Both, SMHS.)

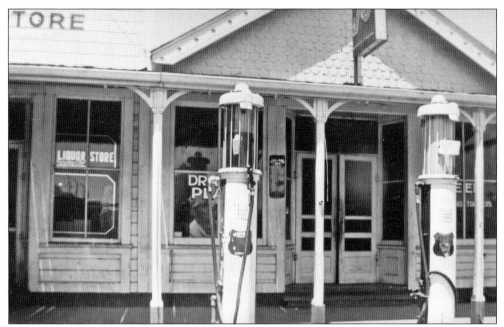

DRAKE'S PLACE. Drake's Place was first located in the building of the former D.A. Ferrari Bar (page 64). John Drake was a Union Oil machinist and opened Drake's Place with his wife, Nita, in the early 1940s. (Courtesy of the Drake family.)

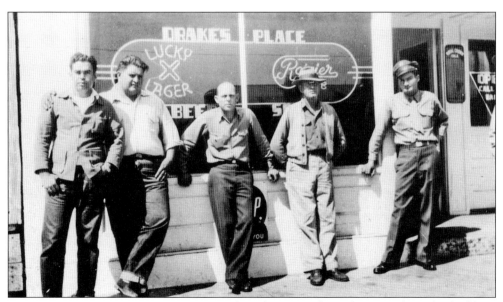

REGULARS AT DRAKE'S PLACE. In 1943, Drake's Place moved two doors north to this building, which was torn down in the mid-1960s. Pictured from left to right are Clyde "Curley" Lopez, Tiny Oster, owner John Drake, Wilbur Kusta, and Leroy Dodge. (Courtesy of the Drake family.)

OLD HEIDELBERG. This building was originally a maintenance garage for San Luis Obispo County. In the early 1950s, Romualda and Carl Trump acquired the building and opened a German restaurant called the Old Mission Motel & Restaurant. It was renamed the Old Heidelberg. In addition to food and cocktails, there was a motel in the back. In the mid-1940s, the bar was called the Oasis. After the Old Heidelberg, the bar was named the Railhead, and it finally became the Moose Lodge about 1989 before being demolished in 2005. It is now a vacant lot. Carl Trump is pictured below in 1951. (Both, SMHS.)

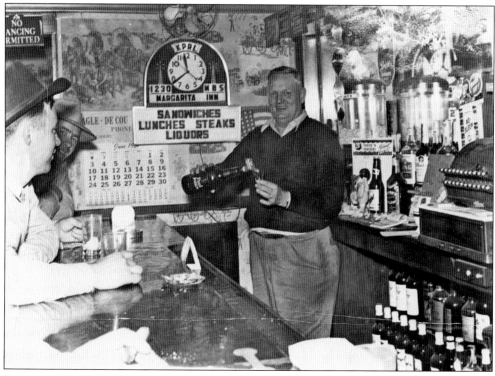

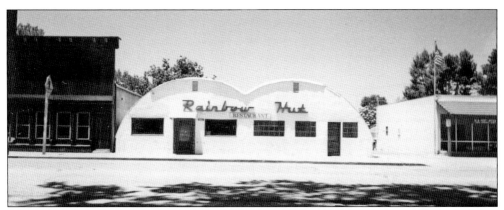

RAINBOW HUT. The Rainbow Hut looks like a Quonset hut but is a plaster-and-lathe building with a corrugated steel roof. Owners Tex and Hilda Murray owned and operated the bar and restaurant, equipped with a pool table, until the early 1980s. The door on the right was added when the law changed to make it more difficult for bars to sell alcohol over the counter. Tex simply put in a false wall and a separate door to comply with the new law. The Rainbow Hut is now an artists' studio. (SMHS.)

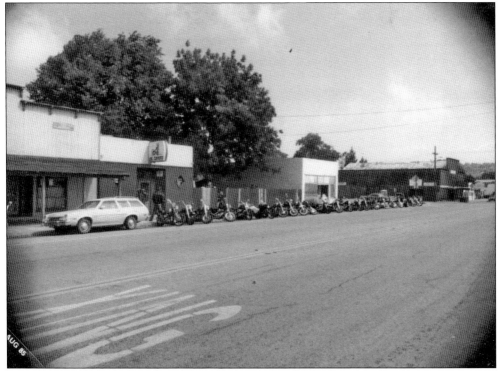

EL COYOTE BAR. A notorious rough-and-tumble bar, El Coyote seemed to attract all types of trouble. Many of the bar owners met with an early and unfortunate death. The building that was Drake's Place is on the right. The location is now a pleasant restaurant serving Southern food. (SMHS.)

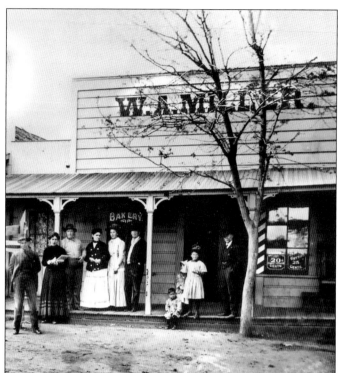

MILLER BARBER SHOP AND RESTAURANT. This 1889 photograph shows William Alfred Miller's barber shop, smoke shop, and bakery. The barbershop and restaurant were just south of the Hotel Margarita on El Camino Real. W.A. Miller continued to run his restaurant until his death in 1938. (SMHS)

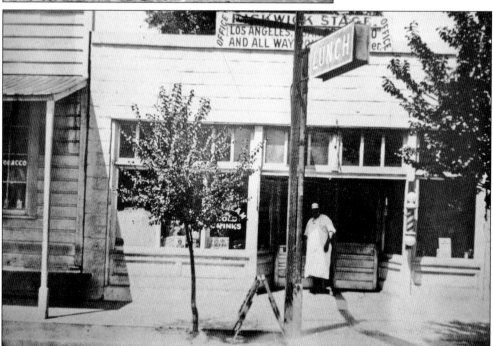

W.A. MILLER. W.A. Miller is pictured outside his restaurant and ice cream shop, which was also the Pickwick Stage Lines bus stop. Dave Miller's barbershop was next door. Dave Miller played in the brass band. The sidewalk in front of the restaurant was laid in 1926, and W.A. Miller's name is still etched in the pavement. (Courtesy of Charlene Miller Edwards.)

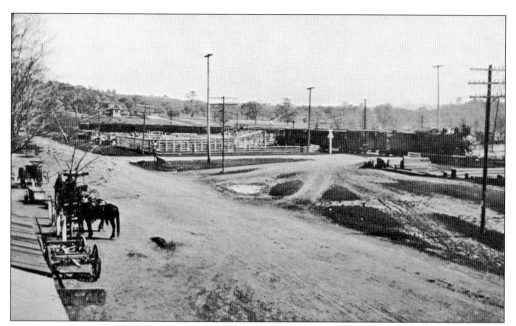

CORRALS. Cattle rancher and Santa Margarita Ranch owner Patrick Murphy saw the advantage of having the train come to him instead of driving his cattle to the train. When the Southern Pacific Railroad arrived in 1889, cattle corrals were already erected at the corner of El Camino Real and Encina Street. These corrals could hold 500 head of cattle. (HCSLOC.)

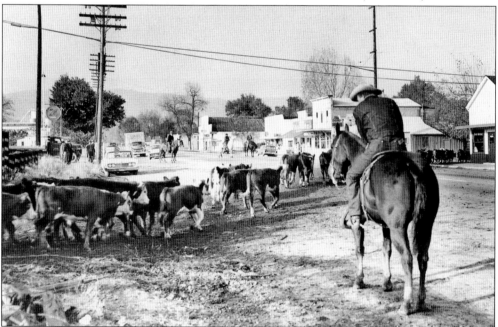

1960s CORRALS. As recently as 1960, cattlemen were still using the original corrals. Gordon T. Davis, pictured here, unloaded 50 carloads, with 2,500 head of Texas cattle. The cattle were driven down El Camino Real to the entrance of the Santa Margarita Ranch at Yerba Buena Street. The constable would stop traffic to allow the cattle onto El Camino Real, which was State Highway 101 until 1958. (HCSLOC.)

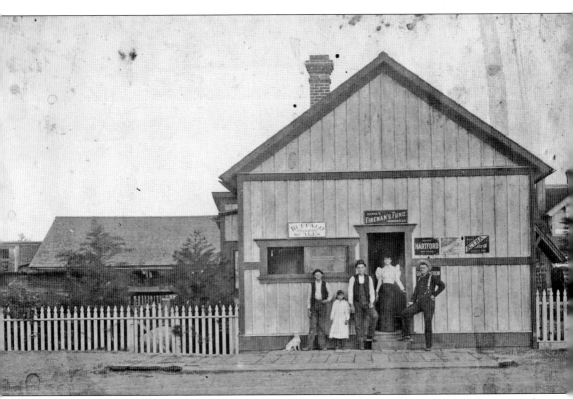

SOUTHERN PACIFIC MILLING COMPANY. S.P. Milling owned two blocks of town from Murphy Street to Encina Street on El Camino Real. The company was not related to the Southern Pacific Railroad, but it built all its mill and feed stores along the Southern Pacific tracks. This photograph of the S.P. Milling office was taken in 1894. J.B. Hill Company, also known as HilCo, bought the land from S.P. Milling in 1950 and continued the feed business until selling to Balfour, Guthrie & Co., shipping merchants, in 1958. (SMHS.)

RALSTON PURINA COMPANY. From 1959 until 1976 this was the Ralston Purina feed business. The truck is probably taking on feed for the turkey ranchers east of town. Turkey ranching provided a handsome living for many local families. When the large hatcheries consolidated their business in the valley, the local families had a very difficult time and many never recovered. (SMHS.)

ERNIE ESTRADA WITH DAUGHTER RAMONA. Direct descendants of Joaquin Estrada, Ernie Estrada and his daughter Ramona are pictured standing on the loading dock at the front of the feed store. The current business, Santa Margarita Feed and Farm, has been locally owned since 1976 at the same location as the original S.P. Milling Company. (SMHS.)

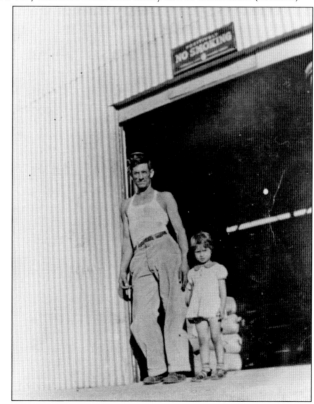

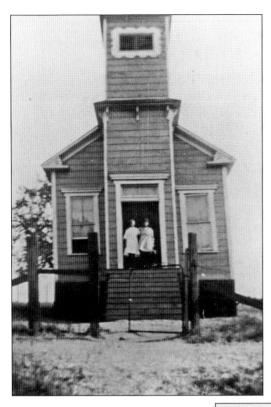

SANTA MARGARITA DE CORTONA CATHOLIC CHURCH, 1906. Santa Margarita de Cortona Catholic Church traces its origins further back than any local church except the Spanish mission San Luis Obispo de Tolosa. The exact location of the first chapel is uncertain, but a site has been noted as part of the National de Anza Historical Trail. In 1905, a vacant building was acquired and moved to the southern end of I Street near the current rectory. This new church was dedicated in 1906. (SMHS.)

HOLY ANGELS CATHOLIC CHURCH, 1935. Following a fire that partially destroyed the 1906 building, this new church was dedicated in 1935. It was built with the salvaged redwood from the burned building, with the remaining materials purchased with a contribution from the Extension Society. The society requested the new church be named Holy Angels. (SMHS.)

SANTA MARGARITA DE CORTONA CATHOLIC CHURCH. In 1988, Fr. Richard Bonjean restored a nearly moribund parish and deteriorated building complex. An active parish council was established and an altar society was formed to aid the pastor with the growing congregation. Fr. Joseph Grech was appointed parish administrator in 1997. He worked to retire a large debt to the diocese and repaint the church gray with white trim. In 1997, Father Grech obtained permission from the Extension Society and Bishop Ryan to restore the parish to its original designation of Santa Margarita de Cortona, a saint of special reverence to the Franciscan order. A gift of an original oil painting by Fr. Sebastian Scicluna depicting Santa Margarita de Cortona hangs in the church (page 11). Today, the church has a growing, vibrant congregation with more than 100 families. (Above, SMHS; below, courtesy of Jill Gallagher.)

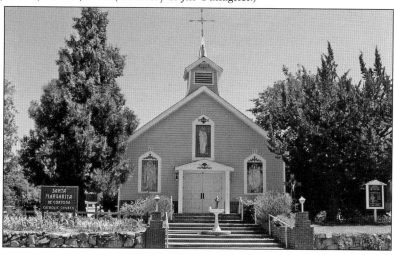

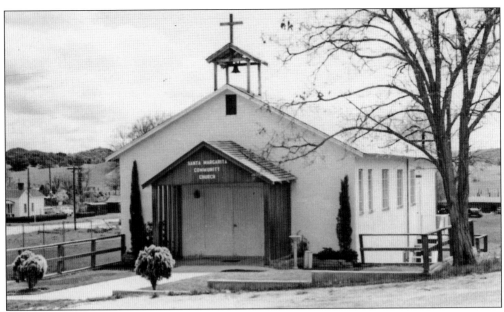

SANTA MARGARITA COMMUNITY CHURCH. The first Protestant church in Santa Margarita was Presbyterian and appeared about 1910. The church was located at the corner of Murphy and I Streets, near the jail and courthouse. During the 1940s, membership had fallen so low that the congregation was disbanded and the church was moved to Garden Farms. In 1949, a new nondenominational Protestant church was formed, and the first Sunday school was held in Velasco's Meat Market. An old pump organ provided the music. Soon the group moved down the street to Proud's Garage. Later, two lots on I Street near Murphy Street were donated by Maude Fotheringham, where the present Santa Margarita Community Church continues. In 1973, materials were salvaged from the former Camp Roberts to build a parsonage. The church had several affiliations before choosing to join with the Evangelical Free Church organization in 1990. (Above, courtesy of the Andy and Hazel Hunter family; below, SMHS.)

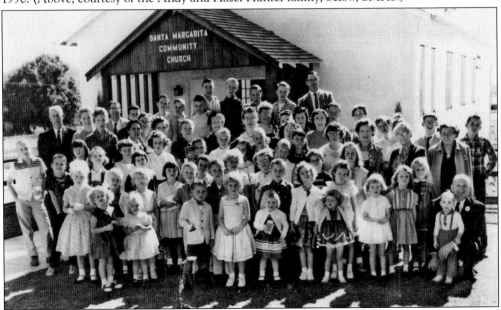

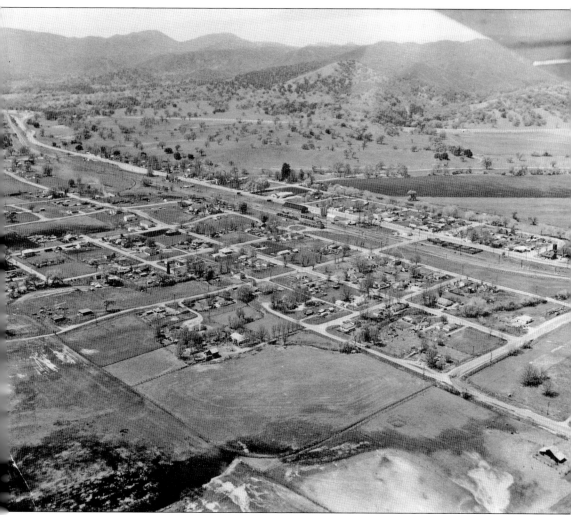

AERIAL PHOTOGRAPH, 1950s. Looking west, this photograph was probably taken when the new Highway 101 freeway was completed in 1957. The new state freeway replaced El Camino Real as the principle north/south route for coastal California and completely bypassed Santa Margarita. Without a nearby freeway exit, most of the garages, service stations, and restaurants closed. However, the bars remained open and continued a brisk business. Highway 58 comes into view at lower left, takes a sharp turn onto Estrada Street, and ends at El Camino Real, which then runs north through town to Highway 101, which can be seen running parallel to the mountains at the top. (SMHS.)

MIKE CORDOVA, "THE OLDEST LIVING COWBOY IN CALIFORNIA." Baptized as a newborn on August 26, 1877, in San Luis Obispo, Pedro Miguel Cordova gained improbable fame as California's oldest living cowboy due to a translation error. Mike Cordova said he was 88 years old when an English-speaking interviewer and a Spanish interpreter interviewed him in 1965. However, the English translation states that "Ol Mike," as he was known, was 108 years old then. It is probable that "Ol Mike" enjoyed the attention that being the "oldest living cowboy in California" brought him, as it doesn't appear that he tried to correct the misconception. Cordova lived a hard life as a vaquero on the Santa Margarita Ranch. He died in 1973 at age 86 and is buried in the Santa Margarita Cemetery. (Photograph by Wilma Pharis, courtesy of Gary Pharis.)

GOV. RONALD REAGAN HONOR. In 1969, Mike Cordova (center) received a statue of a grizzly bear and a plaque from Gov. Ronald Reagan for his 111th birthday. In 1973, he was also honored with a letter from Pres. Richard Nixon proclaiming him, at the age of 115, to be the oldest native son in the state of California. (SMHS.)

MIKE CORDOVA. Emma Mendoza and her grandson, Floyd French, pose with Mike Cordova on the porch of Cordova's house in Santa Margarita. Cordova always wore his Don Hoy hat, which disguised his missing ear. He said it had been cut off by Joaquin Marietta, but Marietta died 34 years before Cordova was born. Mike Cordova never spoke English. (SMHS.)

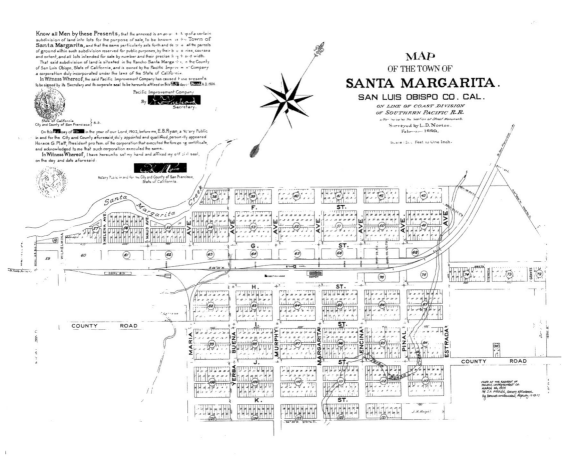

RECORDED TOWN MAP, 1889. To entice the Southern Pacific Railroad to build a railhead near his cattle ranch, Santa Margarita Ranch owner Patrick Murphy gave easements across his land and 640 acres to the Pacific Improvement Company to build the town of Santa Margarita. The site was surveyed into streets, alleys, blocks, and lots. The lots were 25 feet wide and 150 feet long, and there were 32 lots to a block. The main streets running parallel with the railroad are 100 feet in width, and cross streets are 75 feet wide. The original lots were sold on higher land, near the railroad depot, on streets named F through K. El Camino Real is named G Street on this map. (SMHS)

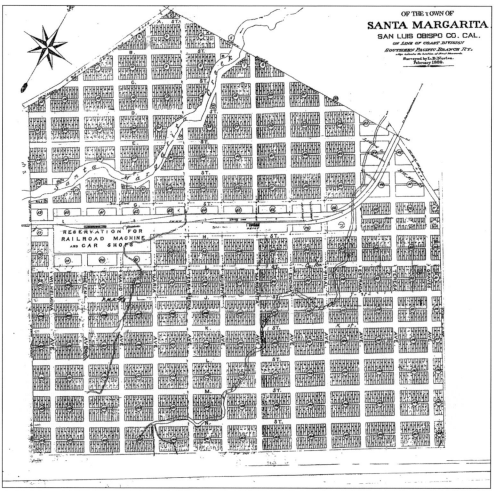

A-N Map. This map was completed in 1889, during Patrick Murphy's ownership of the Santa Margarita Ranch and the development of the town of Santa Margarita. L.D. Norton was the surveyor for this map and the one on the facing page. Neither map was recorded, which was common at the time. When San Francisco land developer Frank Reis bought Santa Margarita Ranch in 1901, he recognized the need for a recorded map and produced one showing F Street through K Street in 1902. In 1989, the current owners of the Santa Margarita Ranch sought to record a "newly found" 1889 map that showed the town of Santa Margarita beginning at A Street and extending to N Street. If accepted, this new map would more than double the size of the town. A petition was filed in San Luis Obispo County Court on December 19, 1989, to ascertain if the A-N map was "destroyed, lost or stolen" from the county recorder. The petition expired without any action being taken. The town of Santa Margarita has not grown an inch since this original map was laid out in 1889. (SMHS.)

DAYS OF THE DONS. California Spanish landholders were considered noblemen and given the honorary title of "Don." The Days of the Dons celebration was originally held at the Santa Margarita Ranch on September 16, Mexican Independence Day. The event was hosted by ranch owner Don Joaquin Estrada after he was awarded the Mexican land grant in 1841. Because the distance to Santa Margarita was great for most of the visitors, the celebrations often lasted more than a month and included rodeos, fiestas, games, and plenty of food and drink. Anglo owner Patrick Murphy continued the tradition after he purchased the ranch in 1860. The celebration was discontinued, but it was revived in 1933 during the Depression as a civic celebration honoring the past while fundraising for future town projects. The celebration occurred sporadically, but it had an almost continuous run from 1965 to 2004. In 1966, the parade included more than 150 entries, more than a ton of beef was consumed, and over 8,000 people visited Santa Margarita for the two-day celebration. The parade's grand marshal and a king and queen were chosen each year for their service to Santa Margarita. (SMHS.)

1968 Days of the Dons. From left to right are Poly Garcia, the 1965 queen; Dave Miller, the 1966 grand marshal; Guadalupe Williamson, the 1966 queen; and LaVelle and Jack Harrington, the 1968 queen and grand marshal. The Harringtons were a fixture of Santa Margarita life for more than 50 years. LaVelle Harrington, only daughter of Ed and Jeannette Spooner, was born in 1897 and married Jack Harrington in 1919. She was a local school teacher until her retirement in 1956. Jack Harrington graduated from college in 1909 and went to work at the Union Oil pump station in Santa Margarita until his retirement in 1956. (SMHS.)

Frank Garcia. A direct descendent of G.S. Garcia, Frank Garcia rides his Palomino mare Golden Girl with a G.S. Garcia saddle for the 1971 Days of the Dons parade. (SMHS.)

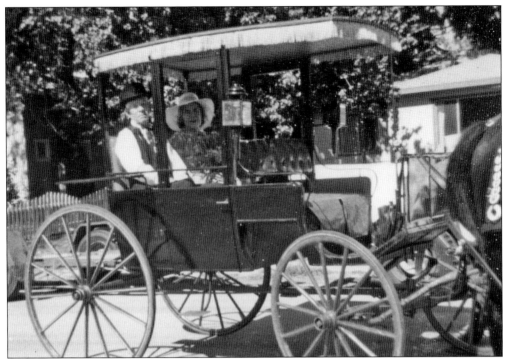

LUIS AND OTILIA SAPIEN. The king and queen of the 1979 Days of the Dons, the Sapiens were born in Michoacan, Mexico, he in 1906 and she in 1907. Luis worked for the Southern Pacific Railroad until his retirement. Otilia Sapien was a homemaker for her husband and five daughters. (SMHS.)

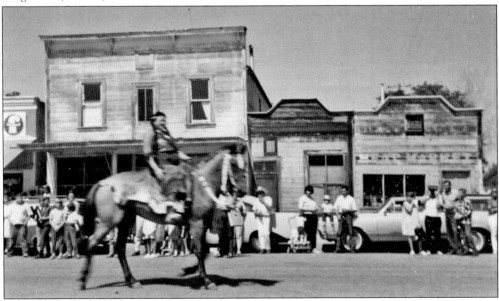

1979 DAYS OF THE DONS. The 1979 Days of the Dons celebration was a two-day affair. The parade had 50 entries, with Boy Scout Troop 123 leading the color guard, marching bands and drill teams, equestrian riders, floats, and antique autos. The festivities included dances, a breakfast, games, and concession booths. (SMHS.)

LITTLE DRIVE INN. The Little Drive Inn was built on the land that once was the Southern Pacific Milling Company's lumberyard. Built in the 1950s by Harry Baeker, it was a typical hamburger and malt stand. It had many names through the years, including La Fontaine's, Martin's Drive-In, Sommertime Drive-In, Gardener's Drive-In, Pookey's, and the Rodeo. The building has been modernized and is now the Range, a locally owned honky-tonk gourmet restaurant. (Both, SMHS.)

SANTA MARGARITA CEMETERY. Originally, Santa Margarita had an informal cemetery at the east end of Encina Street on the Santa Margarita Ranch. Since this was impractical for a growing town, a cemetery district was formed in 1909, and it purchased three and half acres from the Santa Margarita Ranch two miles east of town on Highway 58. The cemetery is situated among ancient oak trees. (SMHS.)

UNIQUE HEADSTONES. The cemetery has 1,740 plots, laid out in three sections. The cemetery district serves Santa Margarita and outlying areas. In 1933, the district made improvements, including paving the roads, installing curbs, fixing the headstones, and installing a gazebo. The district has few rules regarding headstones, so this cemetery features elegant and whimsical designs. (Courtesy of Cat Evans.)

Six

RURAL SANTA MARGARITA

At the beginning of the 20th century, the Union 76 Santa Margarita Pipeline provided good-paying jobs for the men in town. At the time, the only steady, permanent jobs required a sizable investment in a business, a ranch, or a farm. The pipeline operation allowed local men to have a good job, marry, and raise a family without moving away. Today, it is a highly automated plant operated by Phillips 66 Pipeline.

Eighteen miles east of Santa Margarita, Pozo was a turn-of-the-20th-century boomtown on the Butterfield Overland Mail Stagecoach Route. Santa Margarita provided the closest rail transportation. Once Highway 58 (also called Calf Canyon Highway, Old Highway 178, and the Blue Memorial Highway) bypassed Pozo, the town fell into a deep slumber. All that is left in town now is the Pozo Saloon.

Once a bustling agricultural and mining area, La Panza was so isolated that, more than 50 miles to the west, Santa Margarita was the closest western point for commerce and rail transportation. At harvest time and at the beginning of the Gold Rush, the La Panza area saw hundreds of men working, including Mexicans and Chinese. Nothing is left today.

Although the war effort tragically removed families from their land, the building of the Salinas Reservoir Dam and the opening of Santa Margarita Lake provided a boon to the town. Today, visitors from all over the world come to Santa Margarita Lake for the beauty and serenity.

These outlying areas fueled Santa Margarita's prosperity. Santa Margarita's railhead, general stores, hotels, bars, saloons, and pool halls provided necessary goods and services for the miners, farmers, dairymen, and ranchers. Now, Santa Margarita is a sleepy artists' village without a hotel, bank, or franchise outlet. It has not grown an inch since 1889.

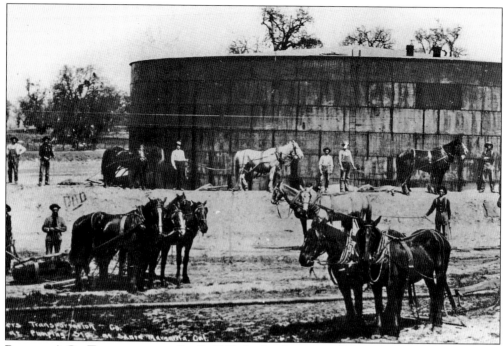

PRODUCER'S OIL TRANSPORTATION CO. By 1909, the San Joaquin Valley was the leading oil-producing region in California. In order to get a profitable price for their oil, 150 small oil companies banded together as the Independent Oil Producers Agency. The two largest oil producers, Associate Oil and Standard Oil, would not give them fair prices. The Independent Oil Producers Agency entered a 10-year agreement with Union Oil for Union Oil to act as their sales agent. Union Oil guaranteed that Oil Producers Agency would receive the same price that Union got for its own oil. (Both, courtesy of Michael J. Semas.)

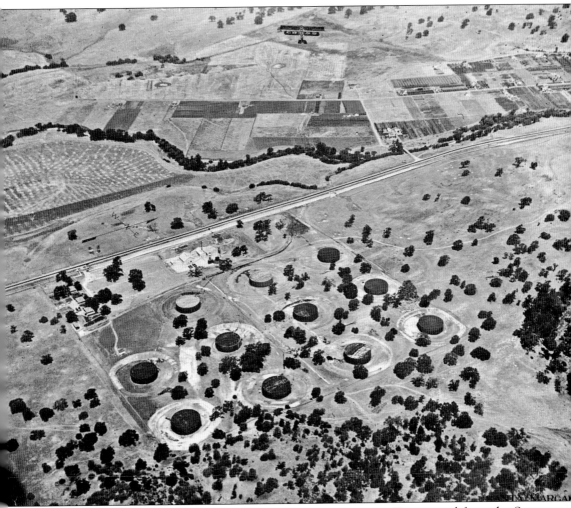

AERIAL VIEW OF SANTA MARGARITA UNION PUMPING STATION. To move oil from the San Joaquin Valley to the sea, Union Oil and Oil Producers Agency jointly organized the Producers Transportation Company to complete an eight-inch pipeline from the valley to Port Harford at Avila. The pipeline cost $4.5 million and consisted of 240 miles of pipe, 15 pumping stations, field tank storage for 27 million barrels of oil, and wharf facilities. Pumping stations for this line began at McKittrick and ran north to Middlewater, turning west at Junction to Antelope, Shandon, Creston, Santa Margarita, and San Luis Obispo before ending at the Union Oil Pier at Port Harford. Eventually, Union Oil bought up the shares until it owned the line. This photograph is from the early 1940s. (SMHS.)

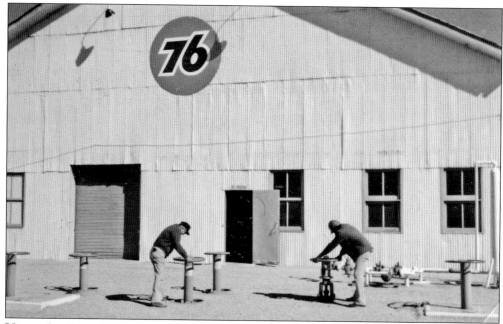

UNION OIL PUMP HOUSE. This building housed the 85-ton Jeansville pump. The building was constructed around the pump (page 114). The valves to the pipelines are shown here being opened manually in 1984 by longtime Union Oil employee Henry Barba (left) and Sam Joes (right). The plant is now highly mechanized. (SMHS.)

JEANSVILLE PUMP. This Jeansville pump was manufactured in Georgia to pump molasses and worked well for pumping the heavy crude oil from the San Joaquin Valley. The flywheel weighed 14 tons and was 14 feet in diameter. It was brought by railcar, then transported by wagons. The pump was decommissioned in 1986 after 76 years of uninterrupted service. (Courtesy of Paso Robles Pioneer Museum.)

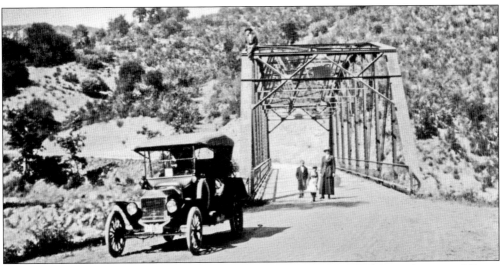

SALINAS RIVER BRIDGE. The Salinas River Bridge was built in 1914 three miles east of Santa Margarita over the Salinas River on the new Calf Canyon Highway, which was built to shorten the route from the Central Coast to the San Joaquin Valley. It was an important crossing for more than 80 years before being replaced in 1996 by a new bridge to the north of the realigned highway. (SMHS.)

LAS PILITAS BRIDGE. The Las Pilitas Bridge was built in 1916 three miles east of Santa Margarita over the Salinas River on Las Pilitas Road and replaced in 2006. These bridges provided better access to and from Santa Margarita. Prior to their building, there were many tales of quicksand encounters and accidents while crossing the river. Both bridges were surveyed and designed by Austin Frank Parsons, a teacher and civil engineer who came to San Luis Obispo County in 1876 and was elected county surveyor in 1903. These two historic bridges, among the oldest remaining Parker truss structures, are today open for pedestrian use only. (Courtesy of Pam Parsons.)

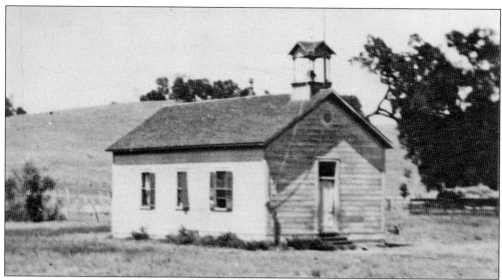

POZO SCHOOL. Seventeen miles from Santa Margarita, Pozo was originally named San Jose and was settled in the early 1800s by Ynocente Garcia. The name was changed to Pozo (Spanish for "well") in 1878 to avoid confusion with the city of San Jose to the north. Pozo had at least three schools; the first (above) was a one-room wooden schoolhouse started in 1869 behind the saloon. It had a potbellied stove that the teacher had to start on cold winter mornings. The second school (below) was called the New School and is still prominent on the little hill on the right driving into Pozo. The New School was built in 1922 with two rooms and a teacher's house next to it. It had a water pump outside and a modern outhouse with two seats and a concrete floor. This school was built of un-reinforced concrete and was abandoned in 1950 due to earthquake concerns. A new school (not pictured) was built a few miles east on the Goodwin Ranch. The final year school was held in Pozo was 1967. (Above, courtesy of Barbara Arnold; below, courtesy of Jill Gallagher.)

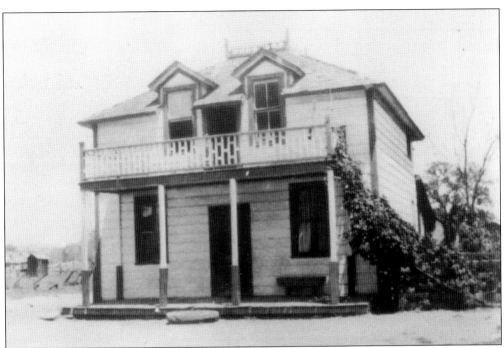

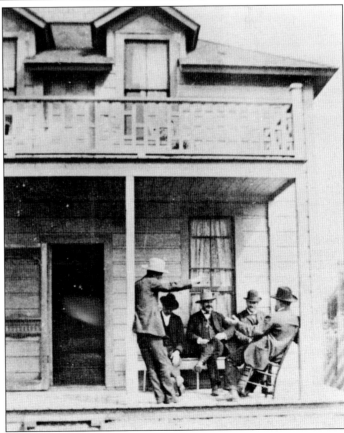

POZO HOTEL. The Pozo Hotel had living quarters on the ground floor for the owners and four bedrooms for guests on the second floor. As a Butterfield Stage Mail stop on the way to the Central Valley, Pozo had many amenities, including two stores, this hotel, blacksmith shops, a school, a post office, and a saloon. The town also had many homes. At the beginning of the 20th century, Pozo was a bustling community. (Both, courtesy of Jon Kelley.)

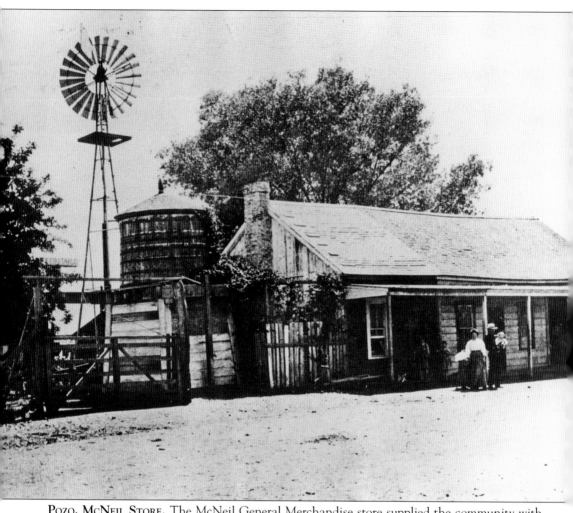

Pozo, McNeil Store. The McNeil General Merchandise store supplied the community with almost everything it needed, including overalls, eyeglasses, shoes, ribbons, underwear, groceries, and drugs. It also had a big candy counter and stables out back. The store housed the post office until 1878, when a permanent post office was created. The post office closed in 1942. Gasoline pumps were added when automobiles became prevalent. Pictured here, Frances Willard purchased the McNeil Store from Alonzo Lazcano and Joseph Hubble in 1899. James W. and Mary McNeil are out front. Although he was not a physician and had no medical training, Francis Willard McNeil did the doctoring for the area. This building was sold and torn down in the 1940s. The Pozo Saloon reopened in 1967, but Pozo no longer has a store, school, or post office. (Courtesy of Jon Kelley.)

POZO, TORRES STORE. The Torres Store was owned by Victor and Sarah Sweet Torres. In 1870, the main route from San Luis Obispo to the Central Valley went through Pozo. The road was later named Highway 178. A rougher wagon road led directly south over the Santa Lucia Mountains to Arroyo Grande (present-day Hi Mountain Road). In 1934, Calf Canyon Highway, also called Highway 58 or Blue Memorial Highway, was completed, and Pozo was isolated once again. (Both, courtesy of Jon Kelley.)

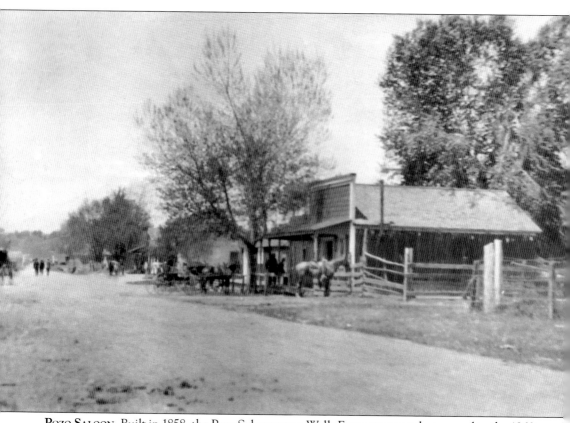

Pozo Saloon. Built in 1858, the Pozo Saloon was a Wells Fargo stagecoach stop, and in the 1860s was on the Pony Express mail delivery route. Due to Prohibition and the highway bypassing it, the saloon closed down in 1920 and remained closed for 47 years. Paul Merrick, former sheriff of San Luis Obispo, reopened the saloon in 1967. The 12-foot-long mahogany bar in the main barroom was brought around Cape Horn in 1860 for a hotel barroom in San Luis Obispo. Merrick purchased it for the Pozo Saloon. The redwood building remains on its original site and still has a wooden hitching post beneath the cottonwood tree that was planted as a sapling in the 1850s. Today, the Pozo Saloon is a popular weekend destination for its rustic setting and live entertainment. (SMHS)

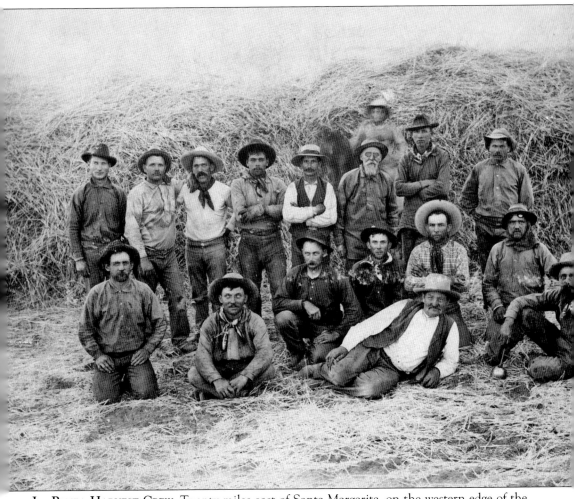

LA PANZA HARVEST CREW. Twenty miles east of Santa Margarita, on the western edge of the Carrizo Plain, is the La Panza Ranch. This photograph is probably from the La Panza Ranch, founded in 1859 and owned by Drury W. James. Drury James was a founder of the city of Paso Robles and uncle to Jessie and Frank James. The James boys spent the winter of 1868–1869 hiding out at the La Panza Ranch. Epifanio Trujillo spotted gold in the Placer Creek at La Panza in 1878. La Panza translates from Spanish as "the paunch" and refers to the practice of using the stomachs of cattle as bait for catching bears. Only a few large ranches remained as the mines petered out. (SMHS.)

LA PANZA, DR. STILL'S DAIRY. In 1879, Dr. Thomas C. Still, a resident of Kern County, took a gold claim a half-mile up Vasquez Canyon in the La Panza Hills. While Dr. Still continued his medical practice and mined, he built a mud-and-stone house with a thatched roof. Dr. Still was granted a post office that he named La Panza for the La Panza gold mines nearby. In 1882, Dr. Still built this wooden-frame house. He moved his small grocery store and the post office into his new house. The post office closed in 1935, the home has burned down, and the stone building is in ruins.

LA PANZA, DOLLY AND WALT DUNNING. Around 1928, the Dunnings were the foremen for the 40,000-acre La Panza Ranch when it was owned by Henry Cowell. Dolly was an equal partner with Walt and would drive the cattle from the La Panza Ranch up the San Juan River and onto the Carrizo Plain. They would drive 1,500 head of cattle, and it would take several days to get them all moved. Later, Walt and Dolly leased 2,000 acres of the La Panza Ranch to run cattle and farm wheat. After Walt was injured in a car accident in 1939, Dolly took over running the ranch until 1946, when they permanently moved to San Luis Obispo. (Both, courtesy of Harold Lowe.)

SANTA MARGARITA LAKE, BLINN RANCH. Land for the Santa Margarita Lake was taken from the Blinn, Maggetti, and Epperly families by eminent domain. The War Department forced families off their land for very little money that wasn't paid for several years and caused hard feelings that remain today. The war ended before water could be delivered to Camp San Luis. (SMHS.)

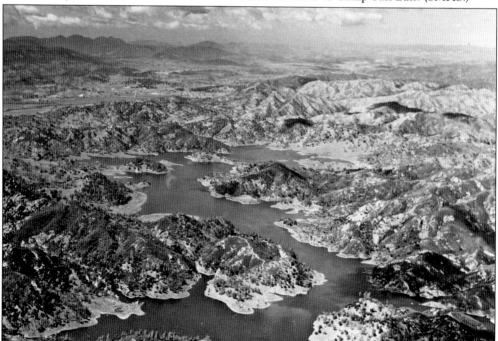

SANTA MARGARITA LAKE. Family ranches like the Blinn Ranch were completely submerged by the rising waters of the lake. The ranch is now under water near the boat docks. (HCSLOC.)

SANTA MARGARITA LAKE DAM. Located eight miles southeast of Santa Margarita, Santa Margarita Lake was created in 1941 with the construction of the Salinas Dam and was originally named the Salinas Reservoir. The dam was built by the US Army Corps of Engineers under executive order to provide water for Camp San Luis during World War II. It cost $1,714,600 and took nine months to build. The dam rises 135 feet above the stream bed and 1,190 feet above sea level. (SMHS.)

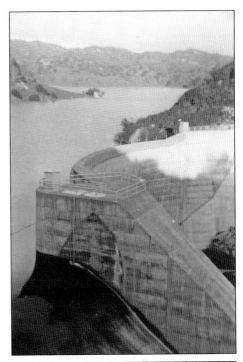

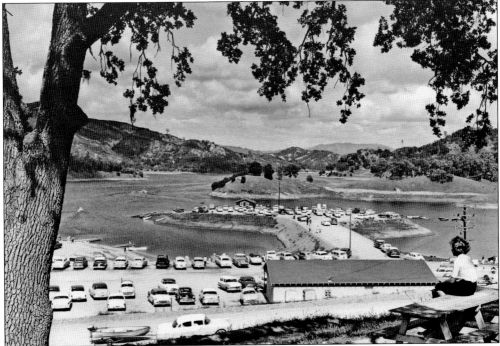

SANTA MARGARITA LAKE RECREATION AND NATURAL AREA. Once the dam was completed, the water was diverted to the city of San Luis Obispo. In 1955, San Luis Obispo County established Santa Margarita Lake as a recreational area. Today, it is a fishing and boating lake. The Santa Margarita Lake Recreation and Natural Area comprises several thousand acres of designated open space for passive use, including hiking, cycling, birding, and equestrian activities. (SMHS.)

Discover Thousands of Local History Books
Featuring Millions of Vintage Images

Arcadia Publishing, the leading local history publisher in the United States, is committed to making history accessible and meaningful through publishing books that celebrate and preserve the heritage of America's people and places.

Find more books like this at
www.arcadiapublishing.com

Search for your hometown history, your old stomping grounds, and even your favorite sports team.

Consistent with our mission to preserve history on a local level, this book was printed in South Carolina on American-made paper and manufactured entirely in the United States. Products carrying the accredited Forest Stewardship Council (FSC) label are printed on 100 percent FSC-certified paper.